Easy Coloring Book For Adults

This Beautiful Relaxing Coloring book belongs to:

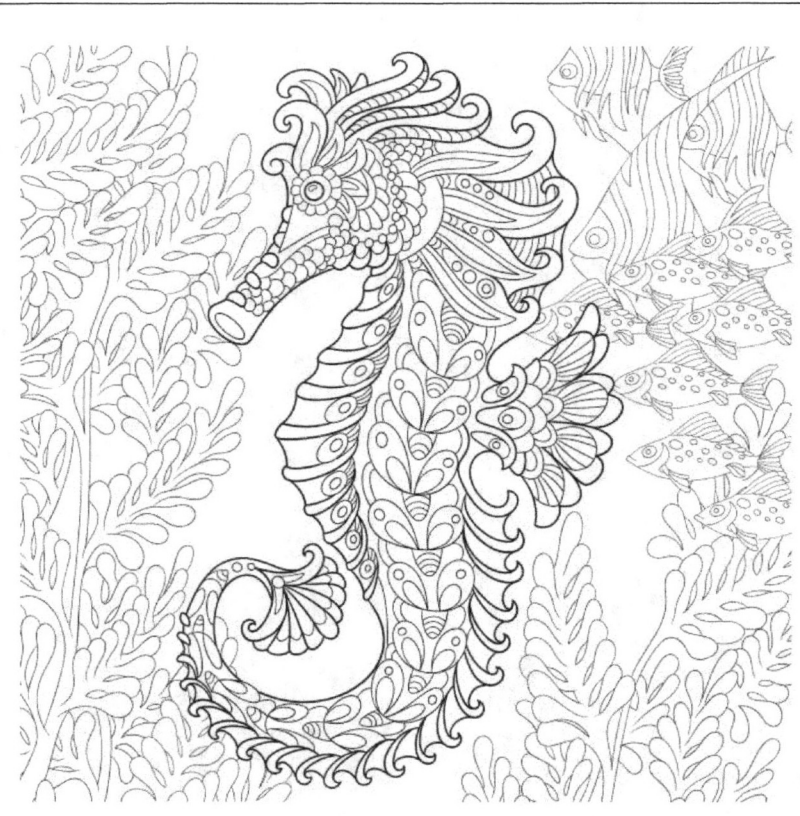

Copyright © 2019 Adult Coloring Books

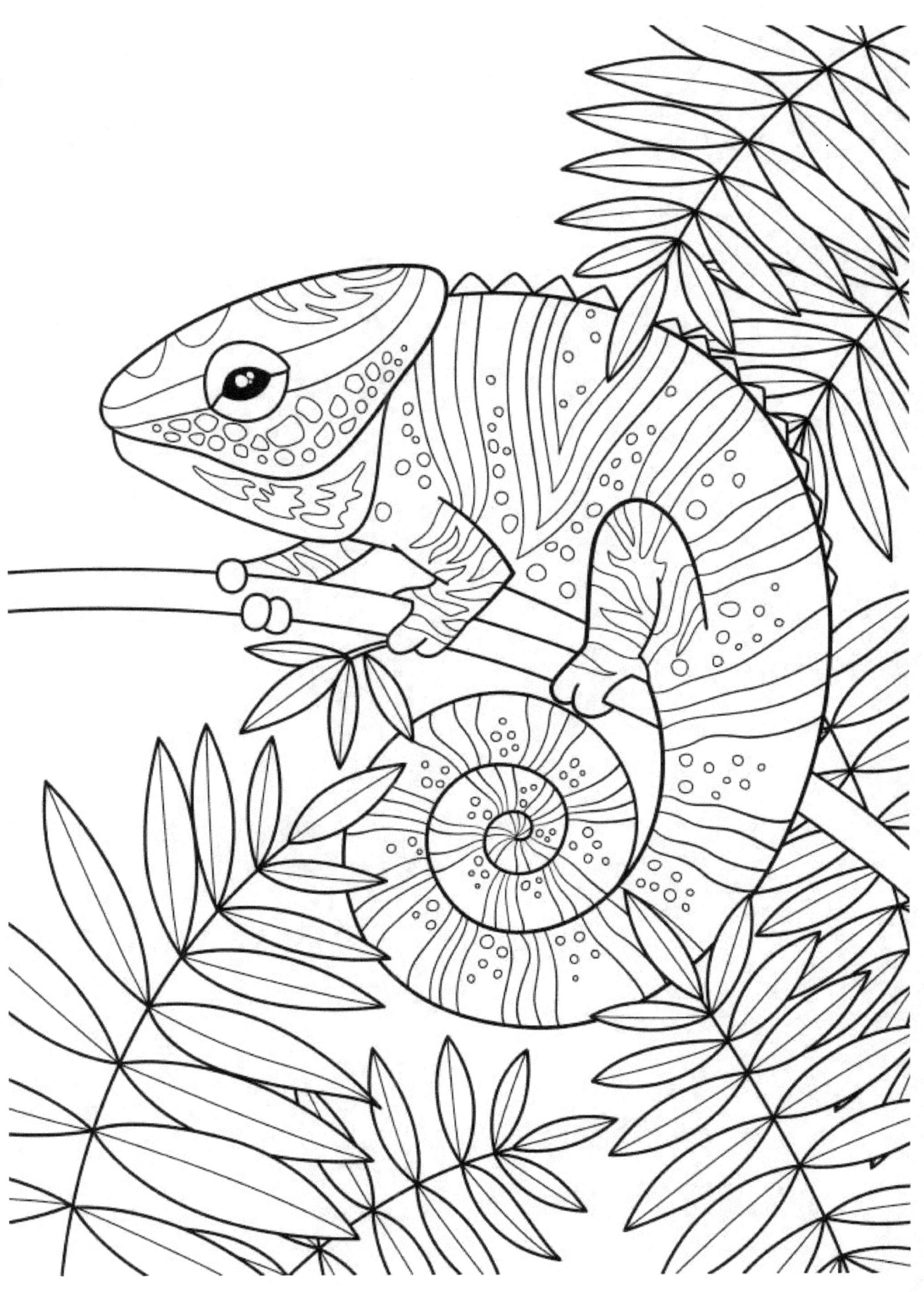

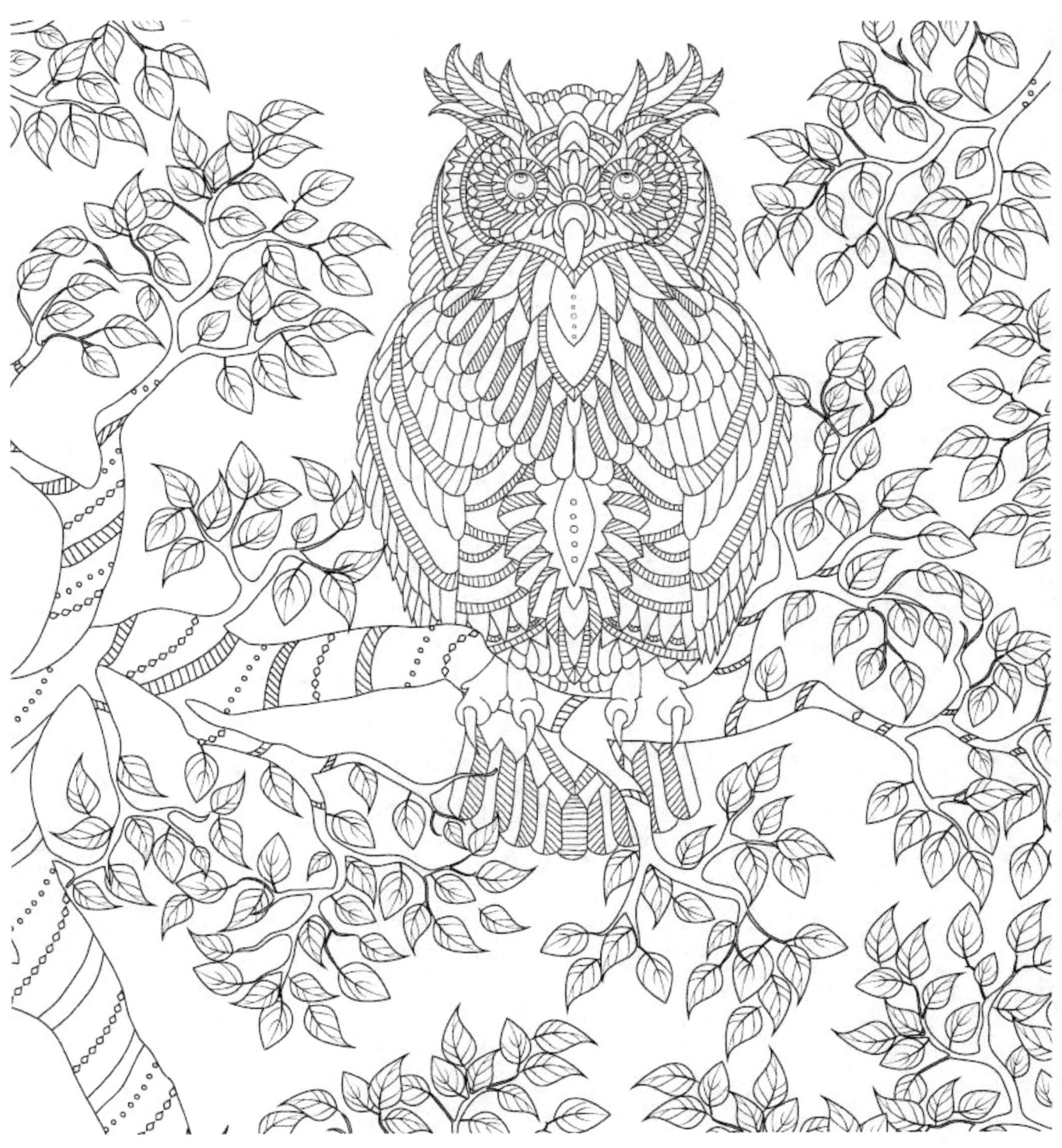

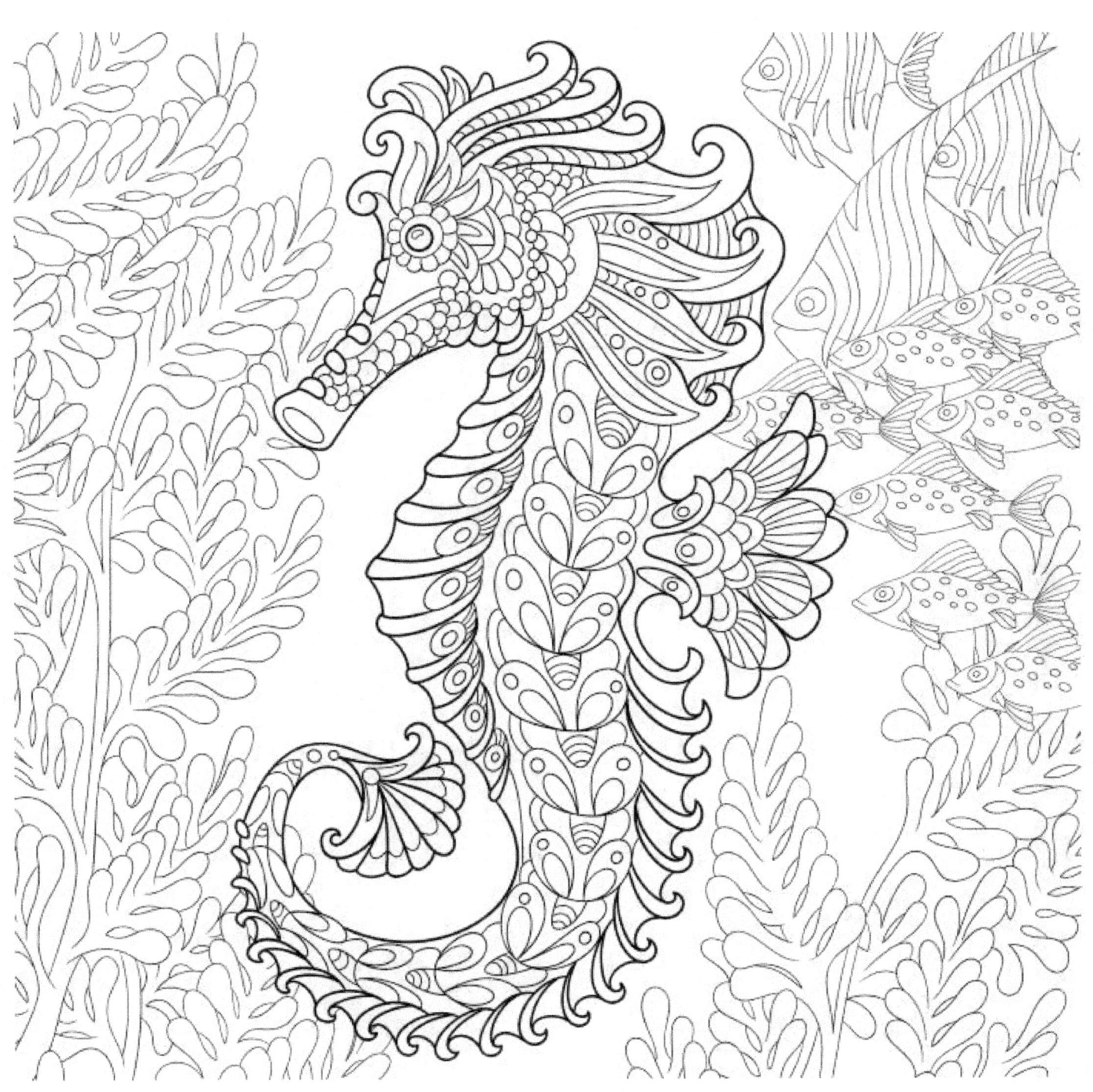

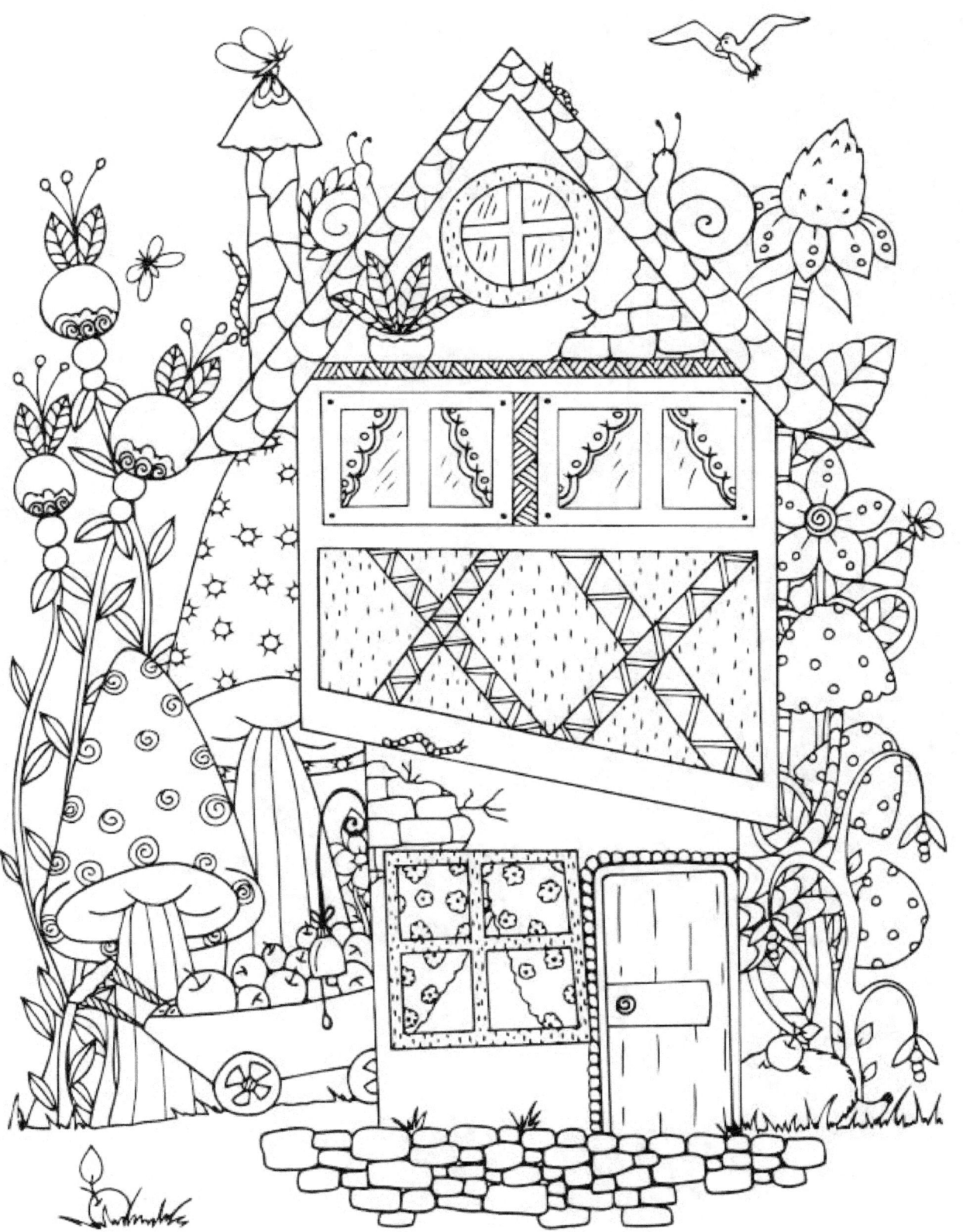

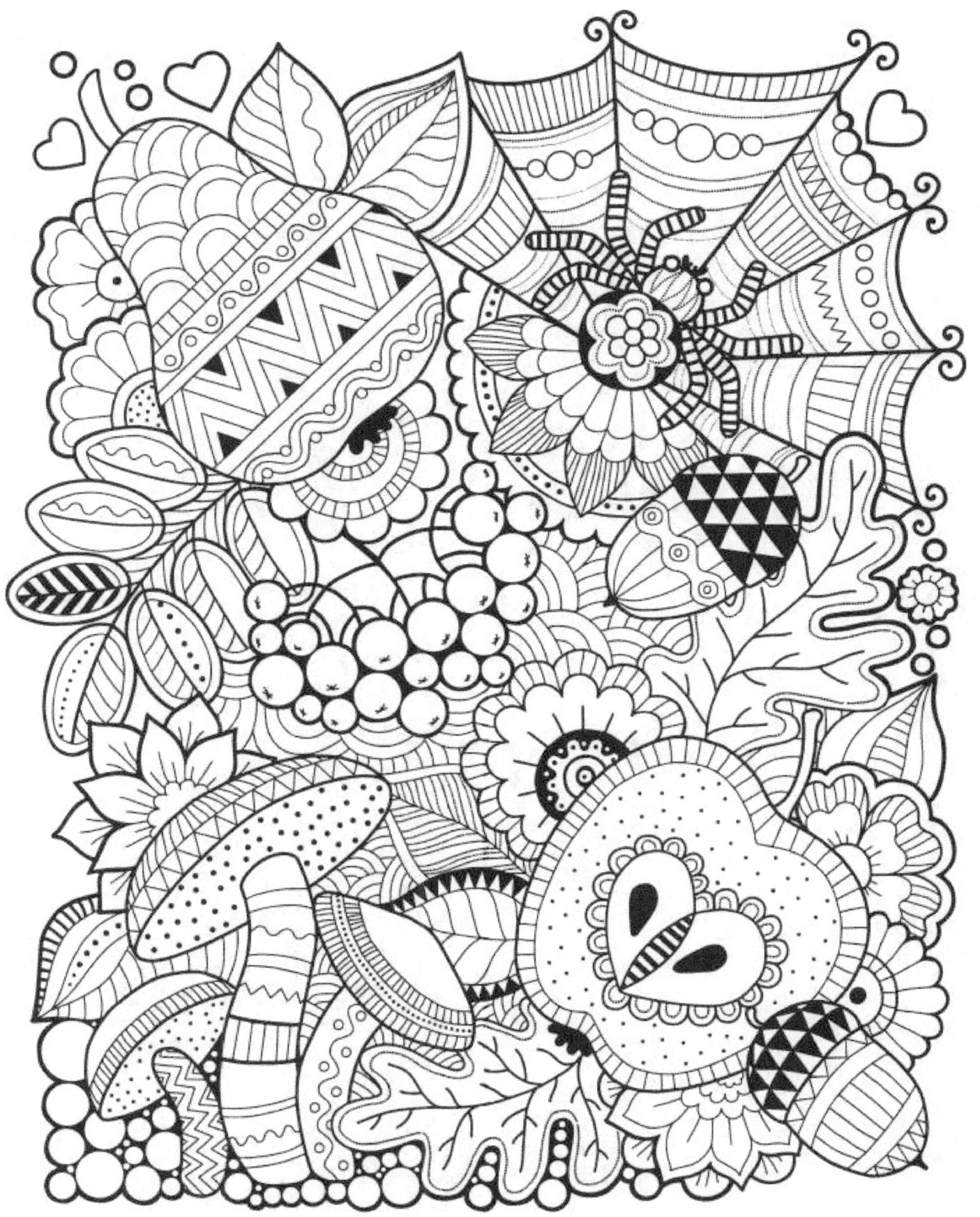

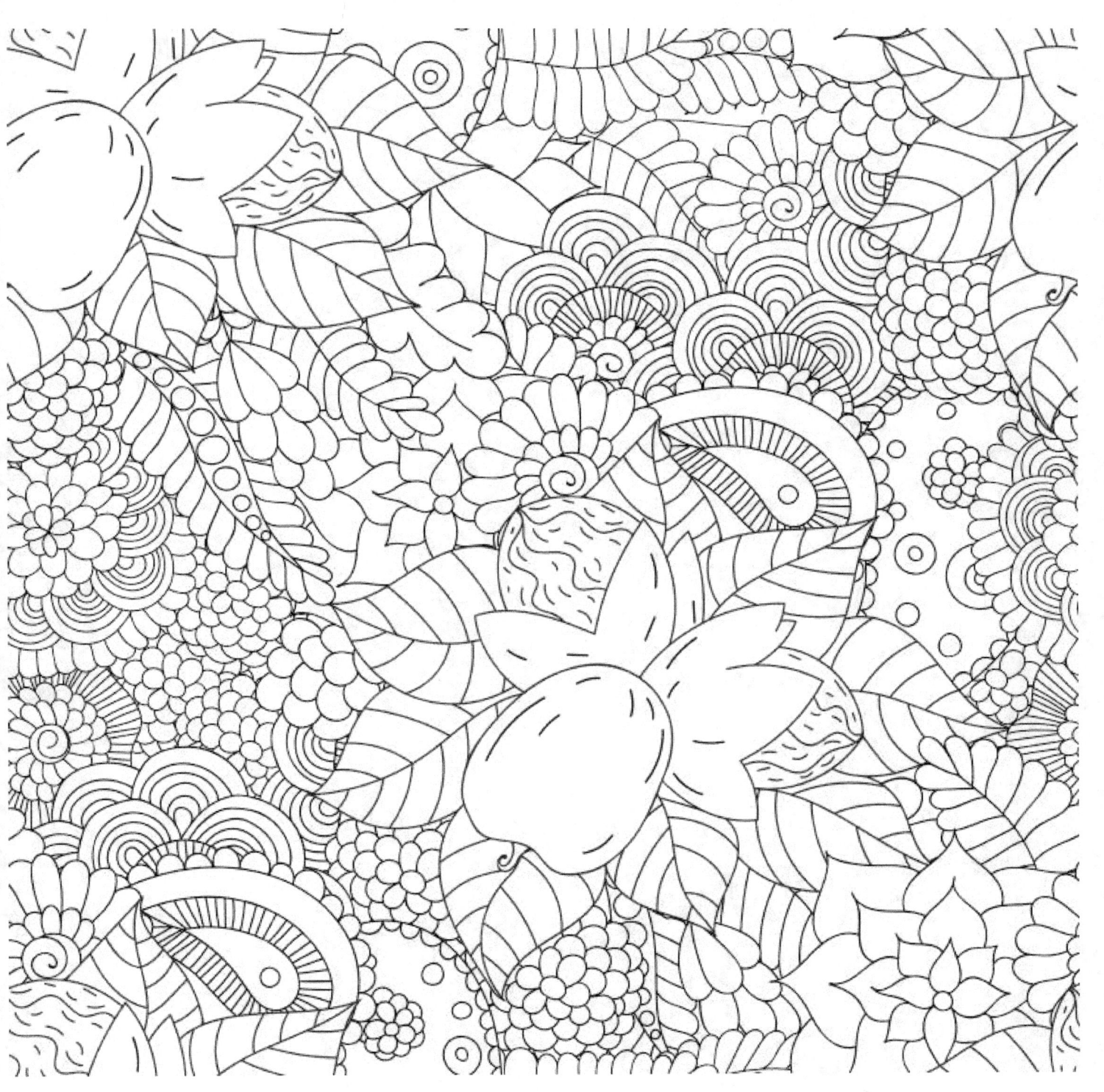

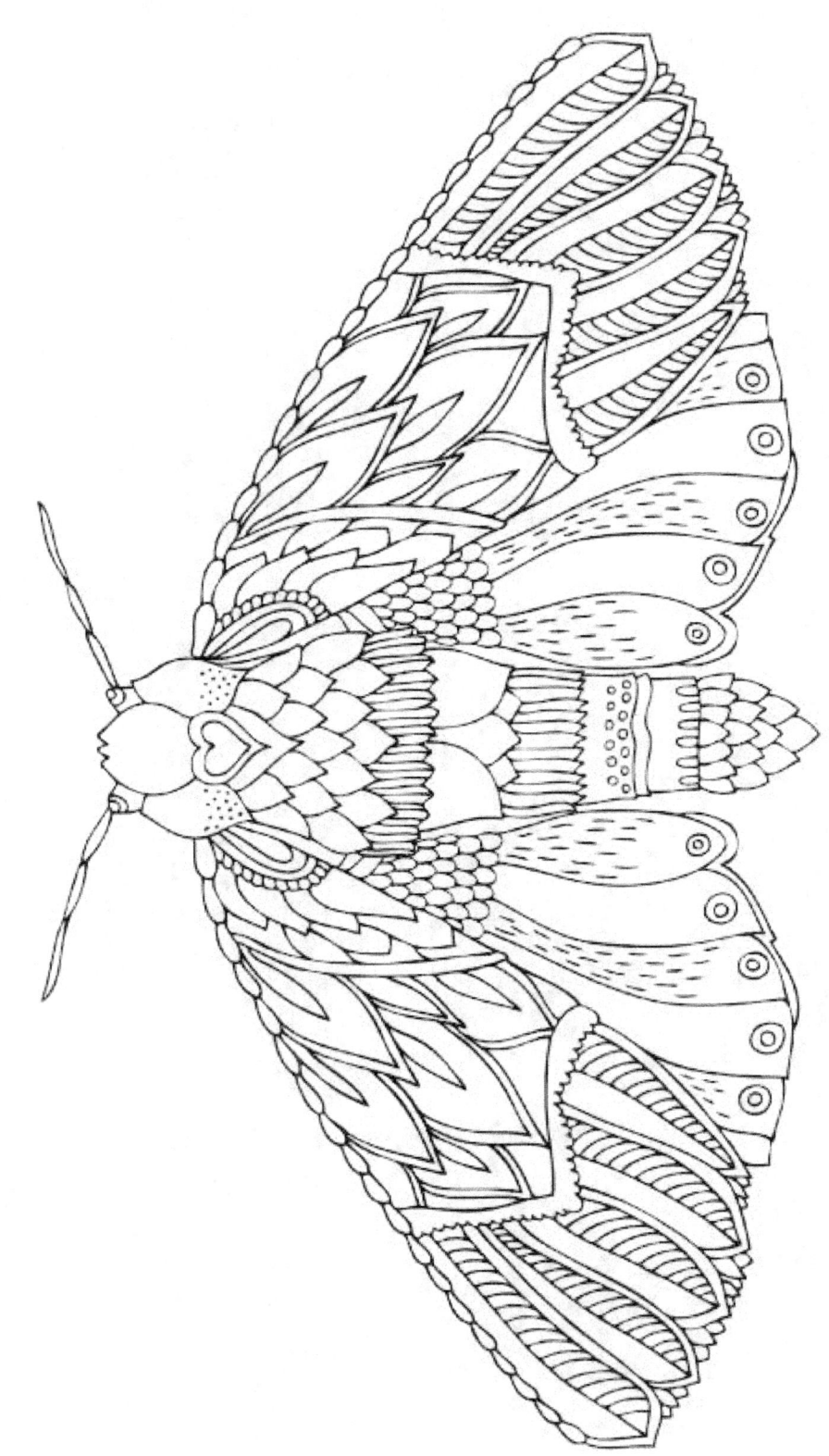

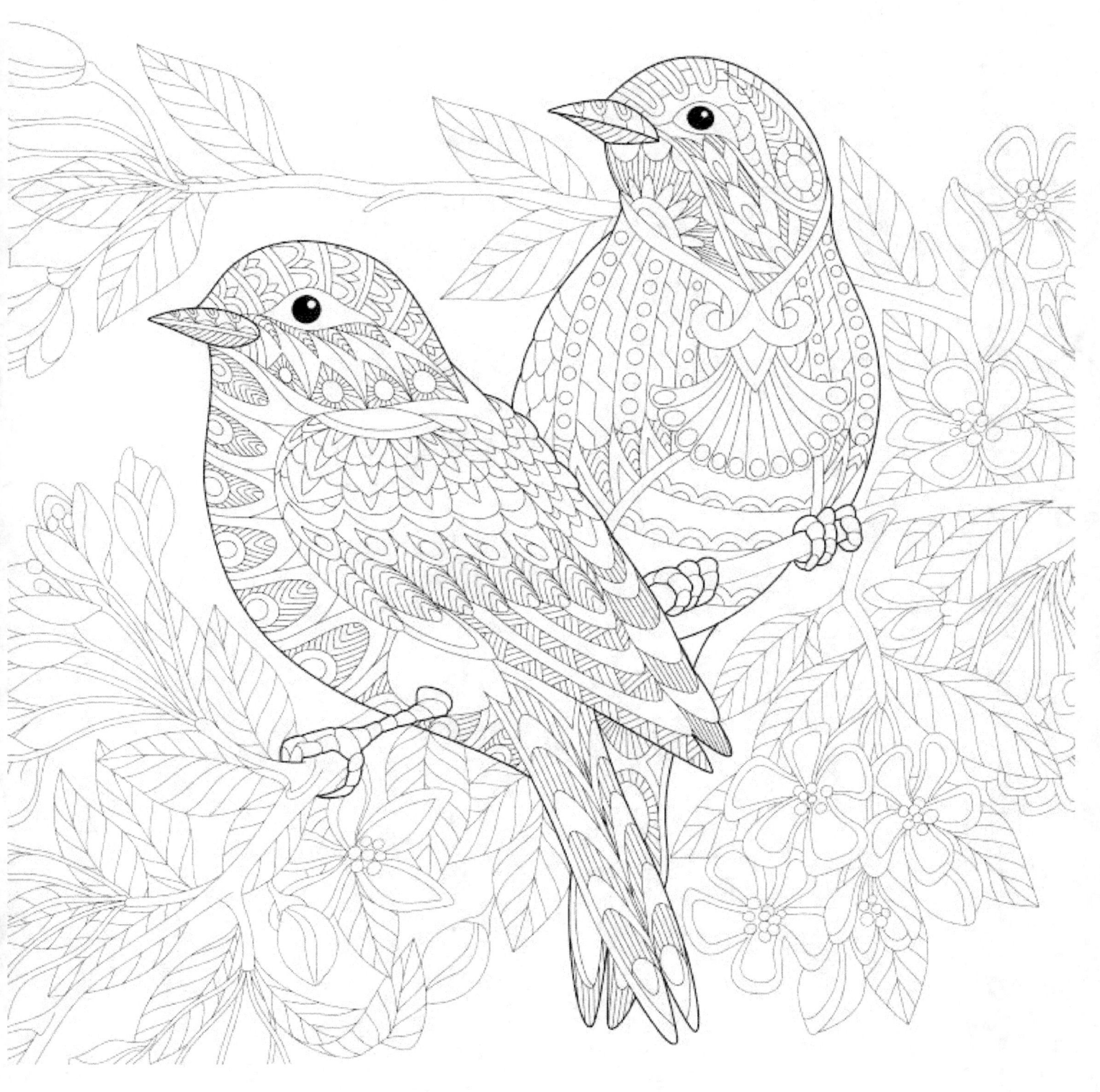

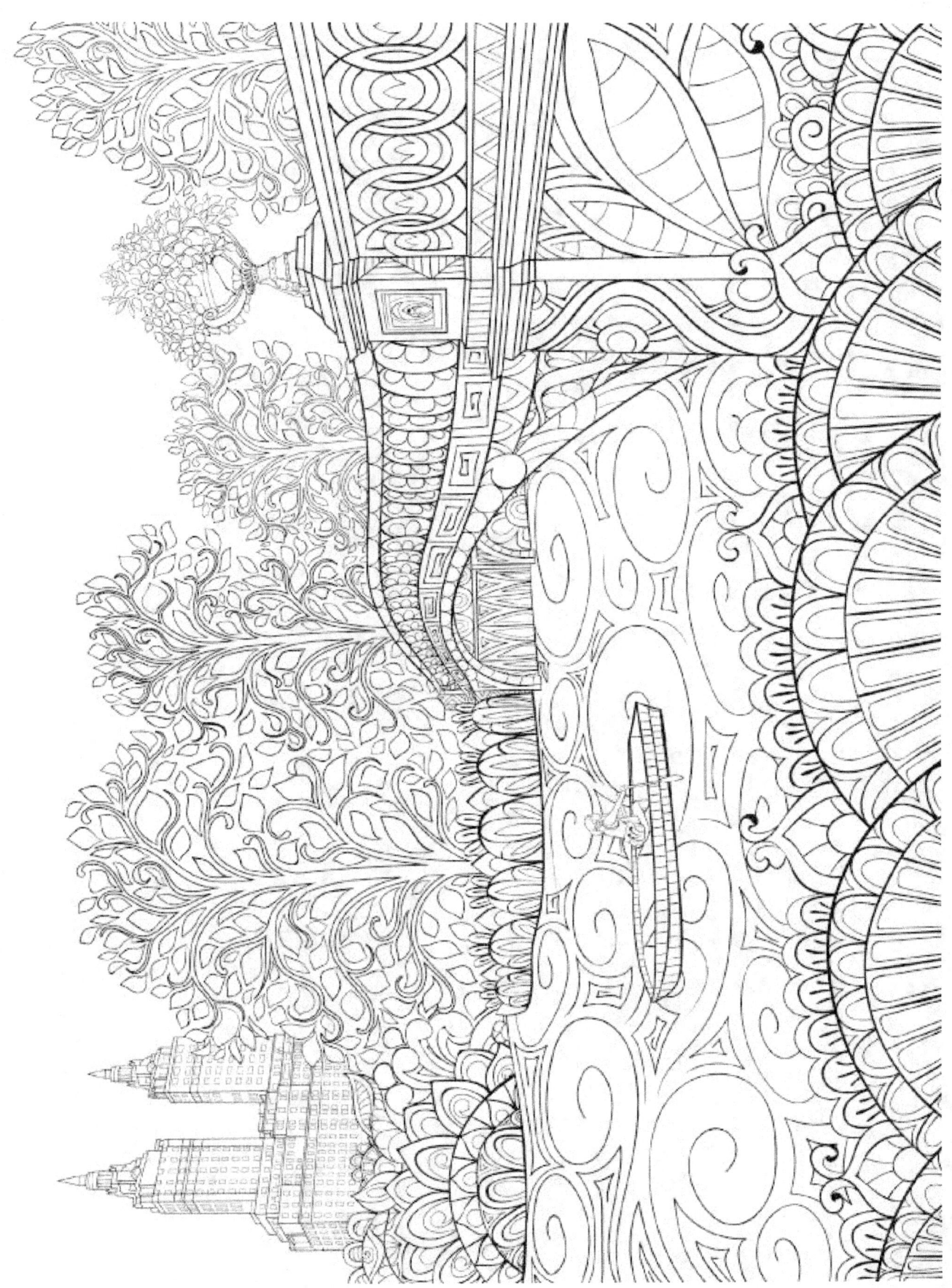

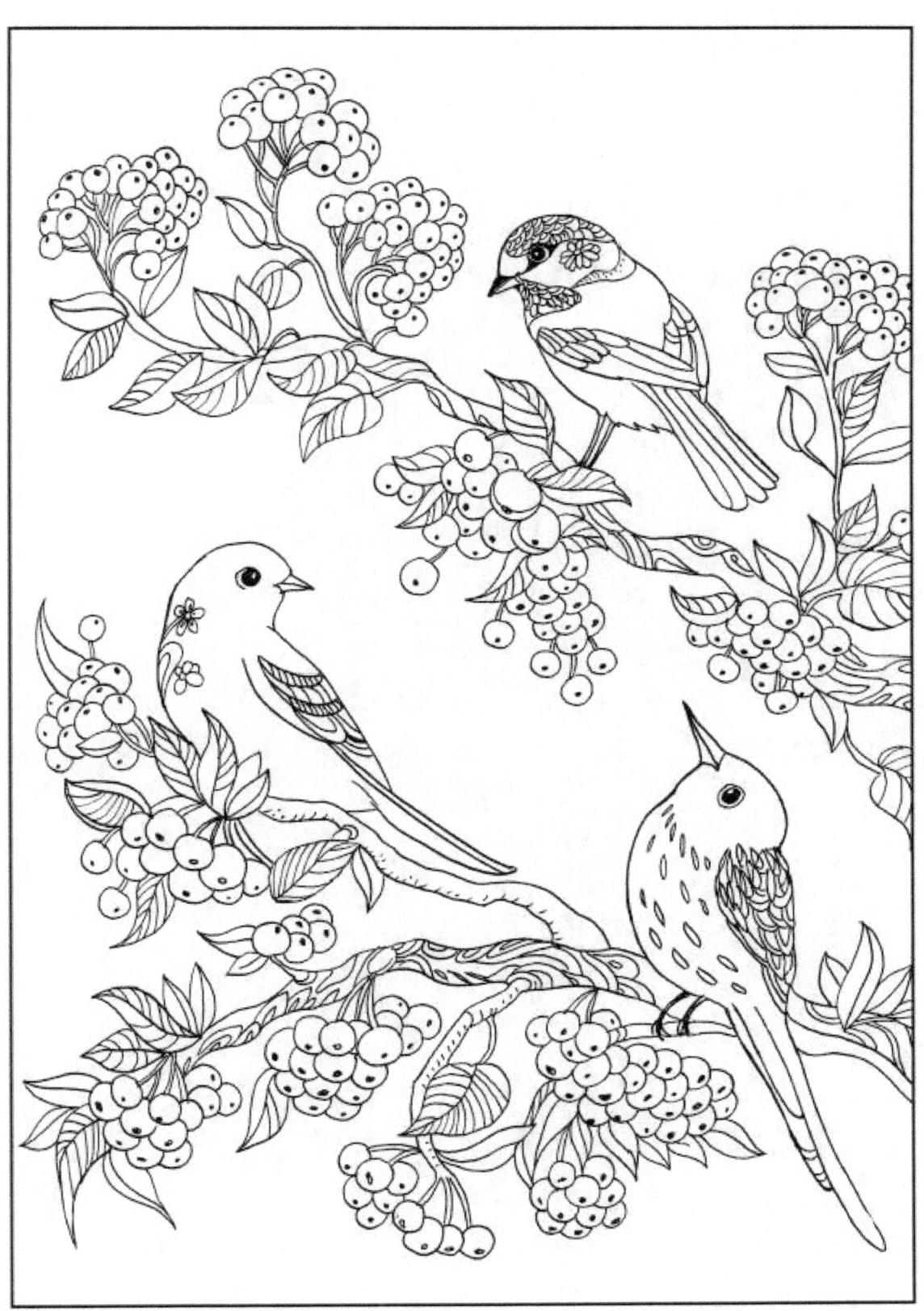

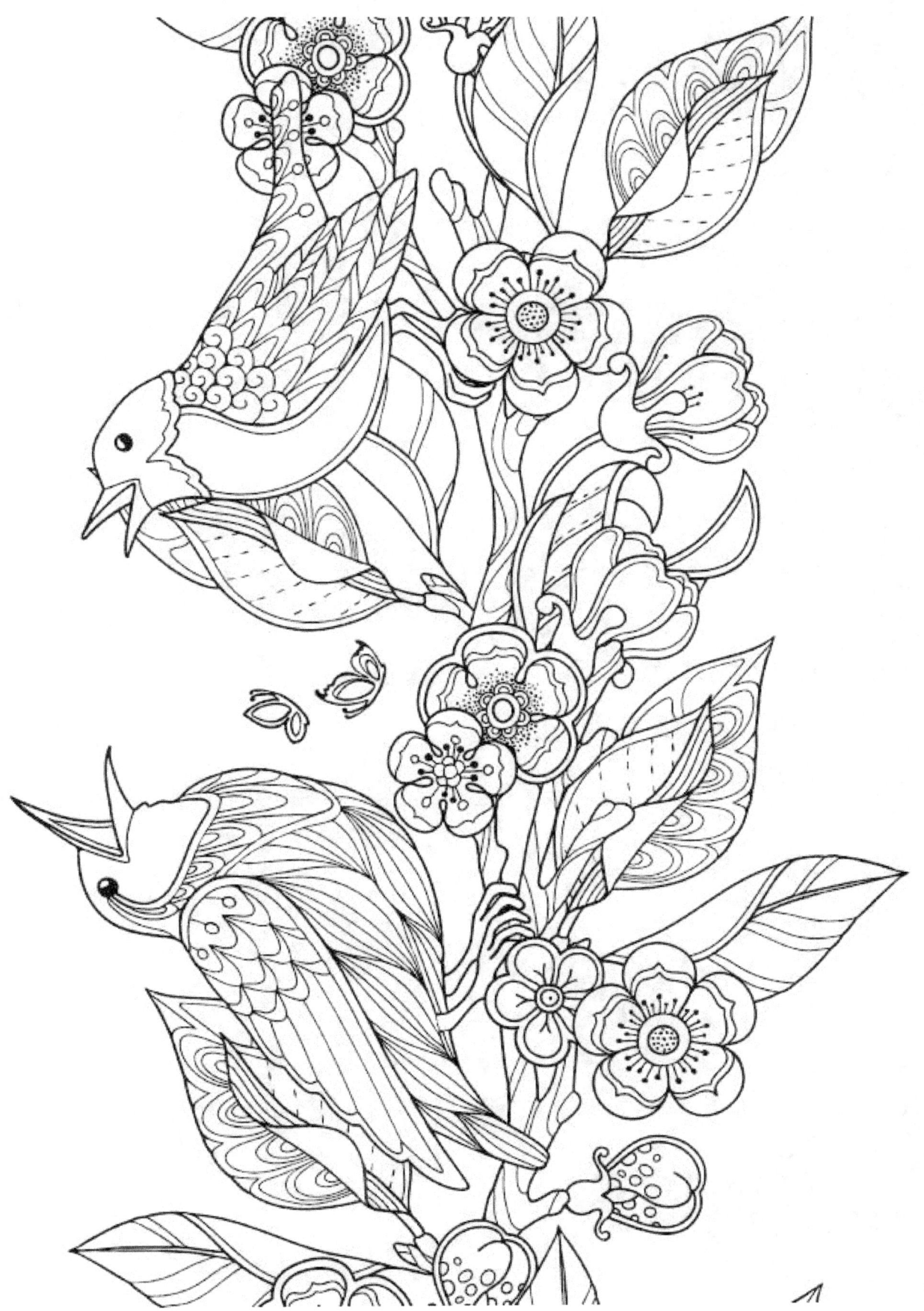

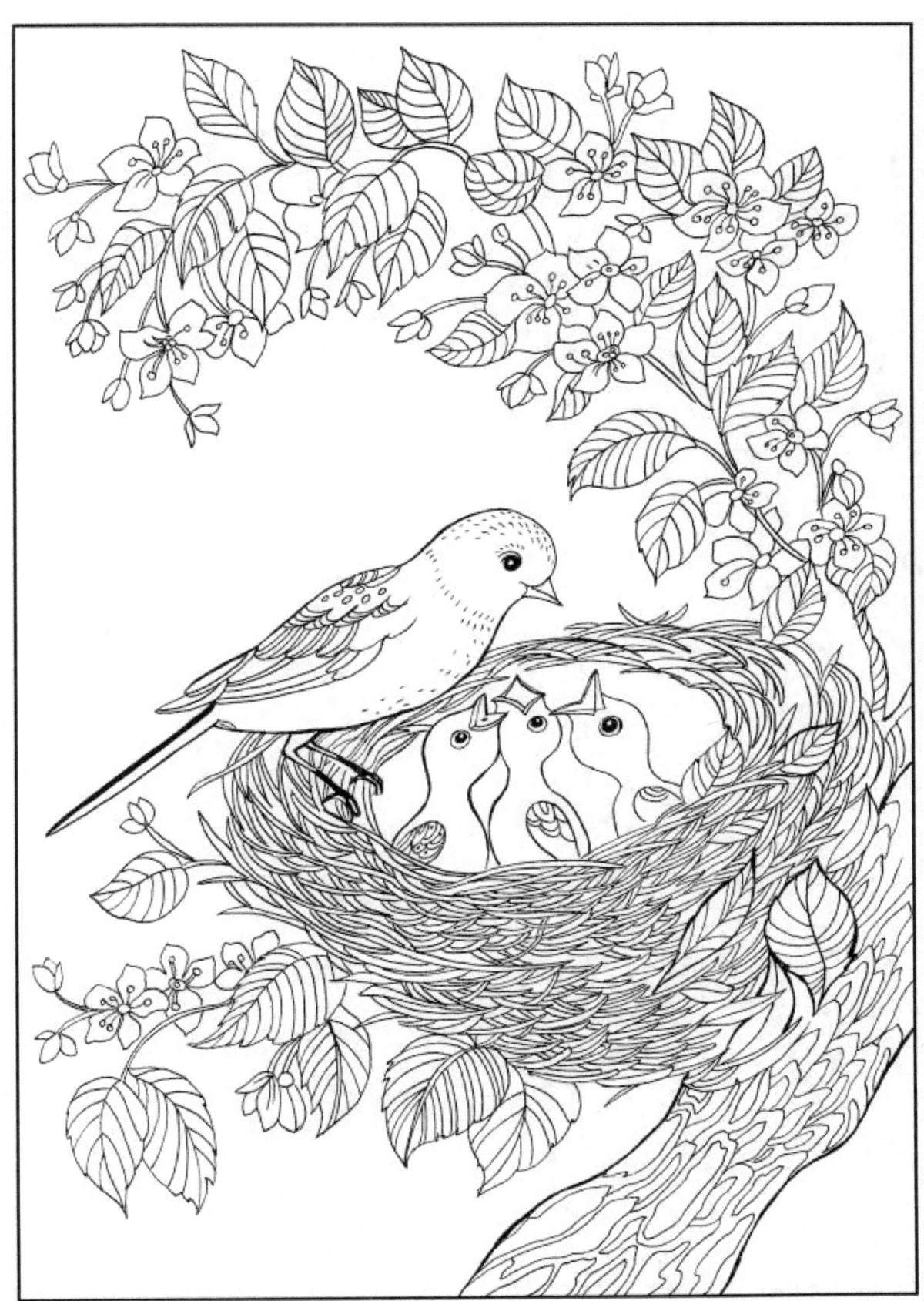

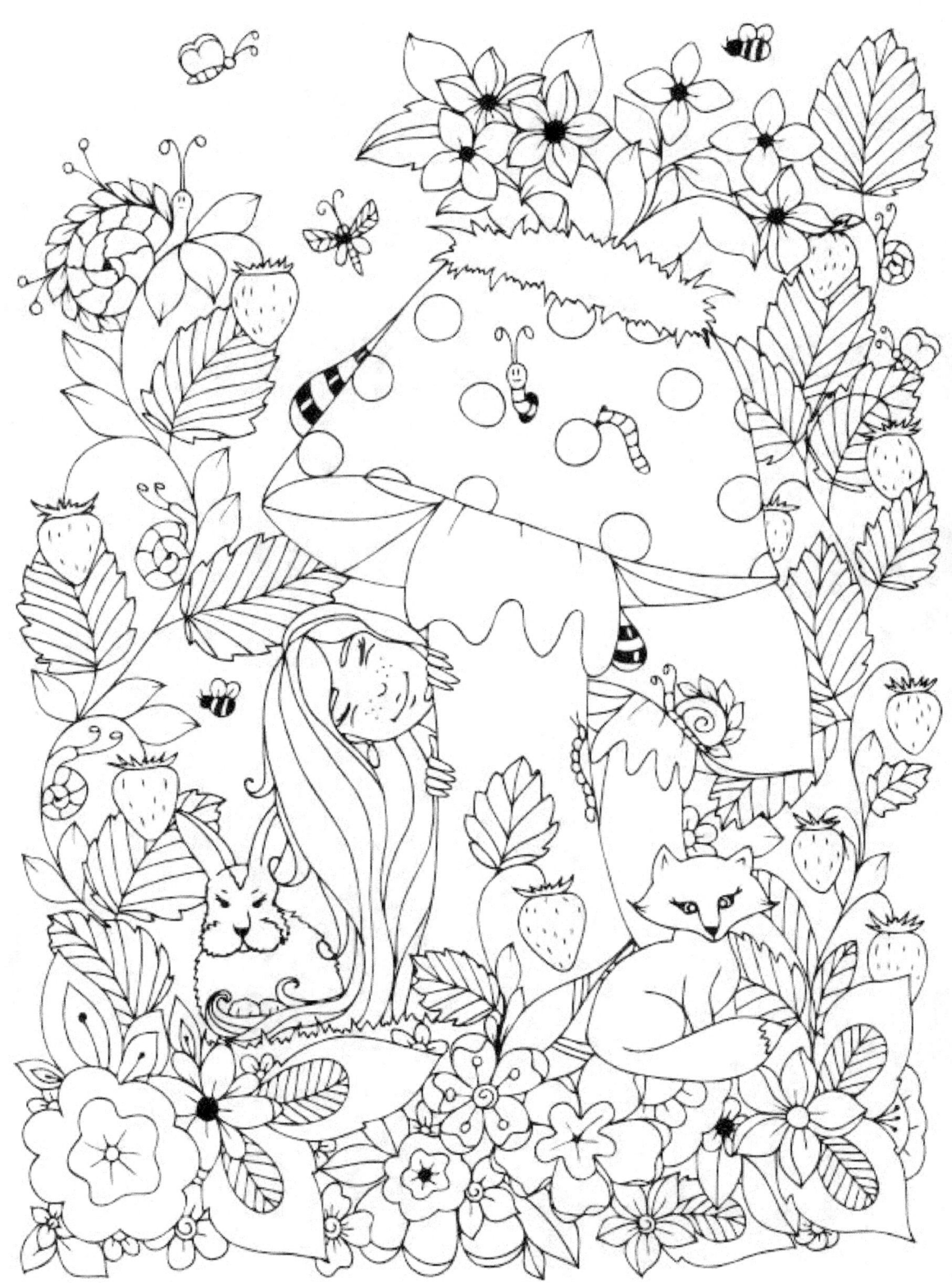

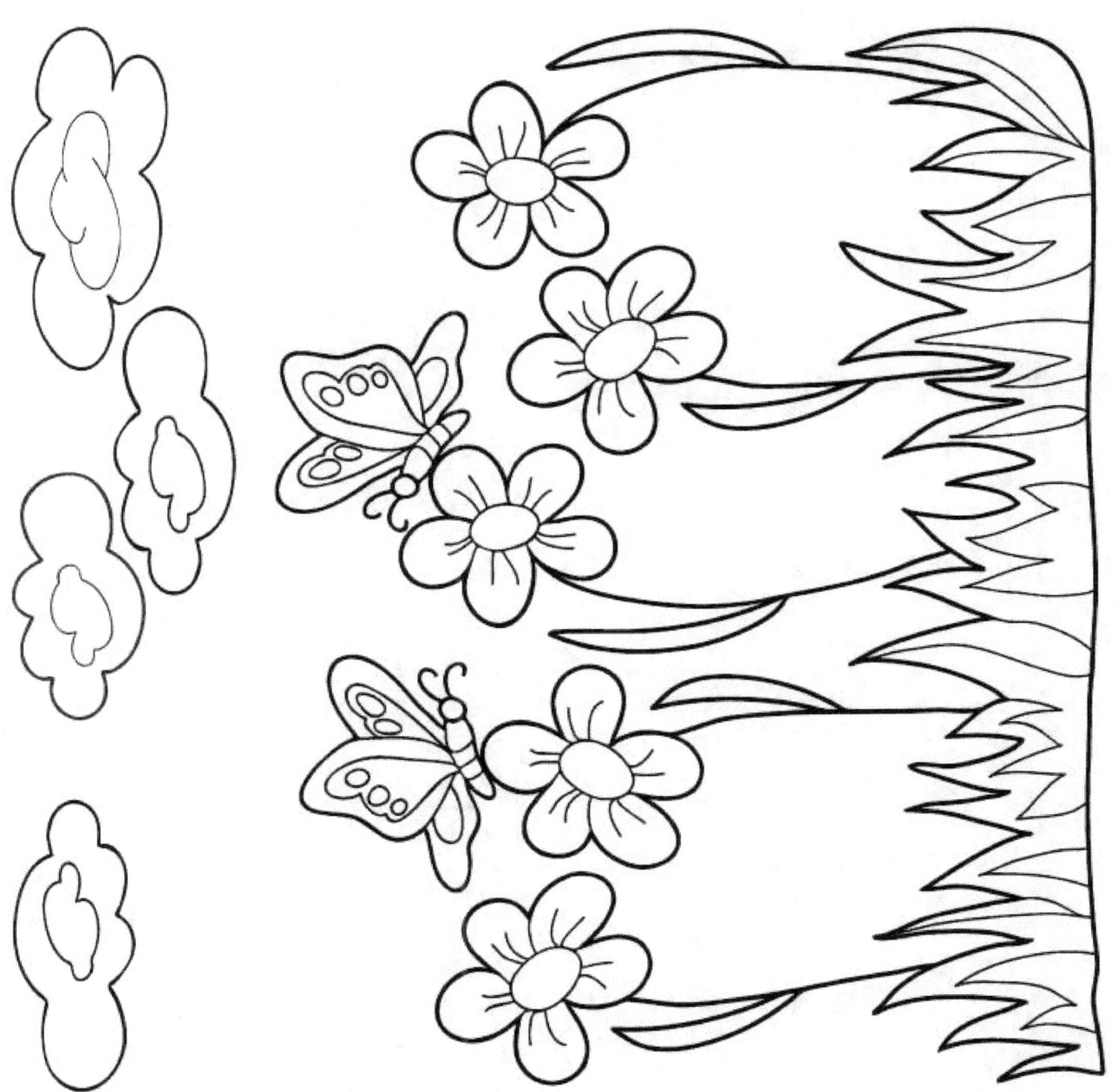

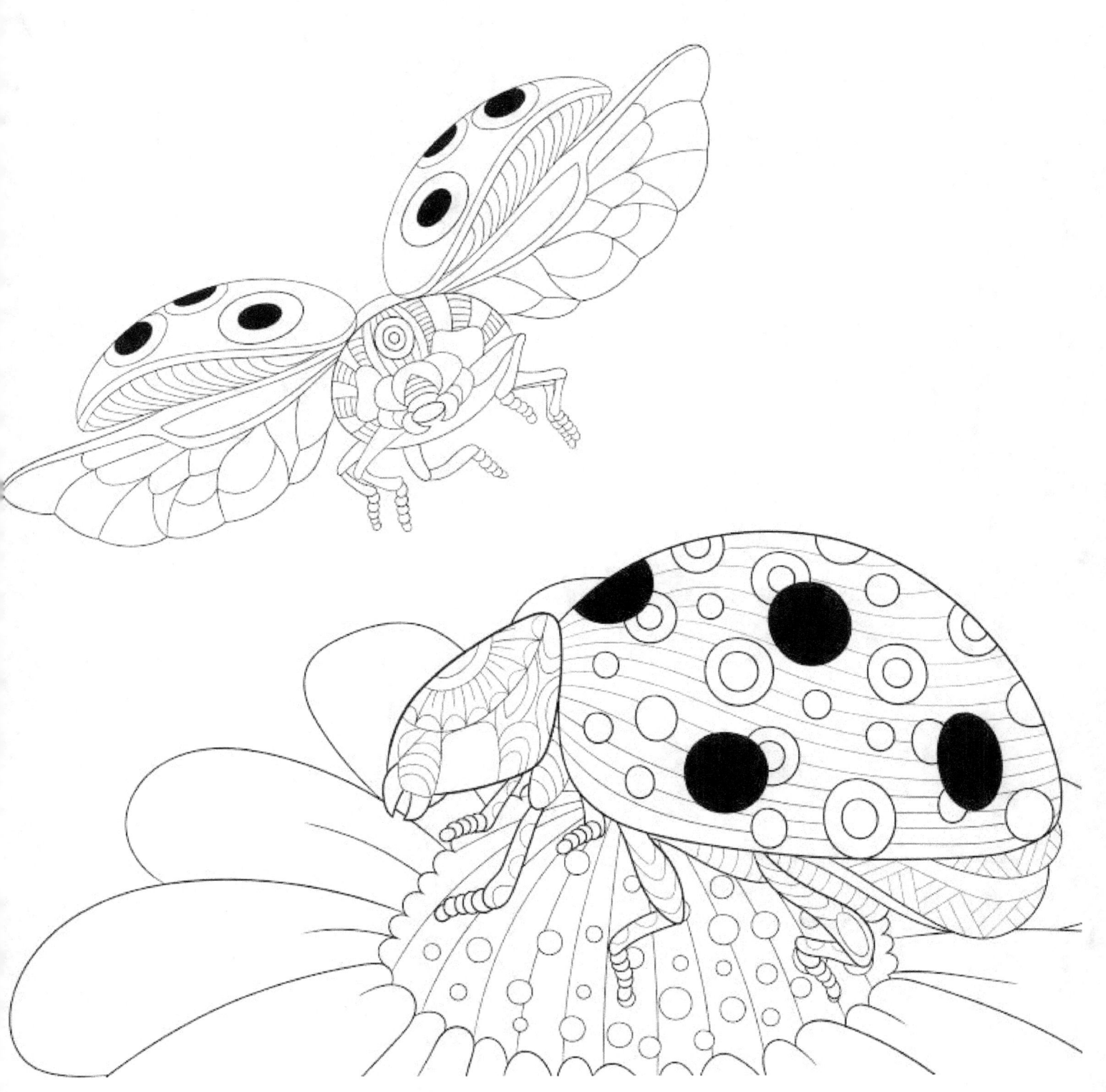

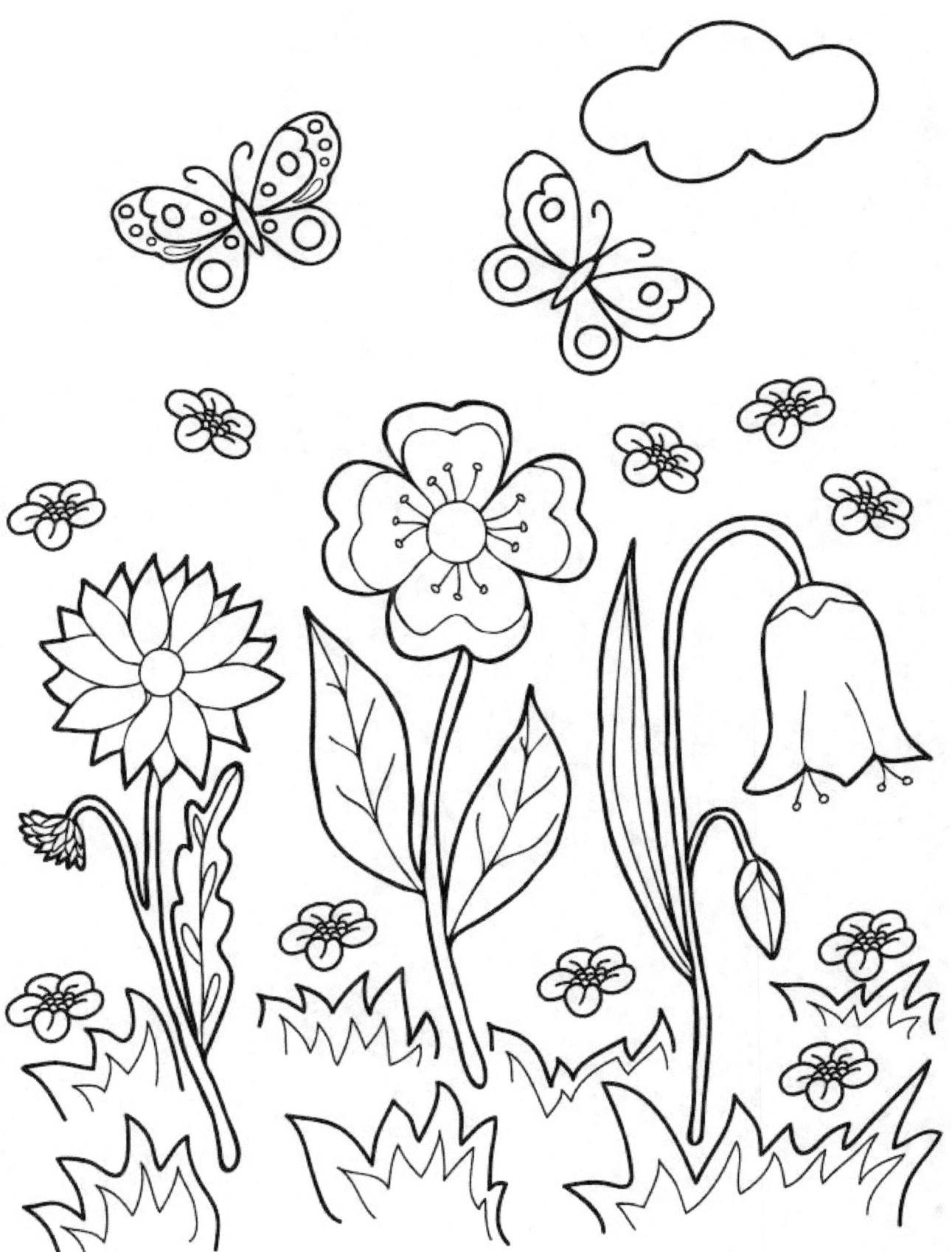

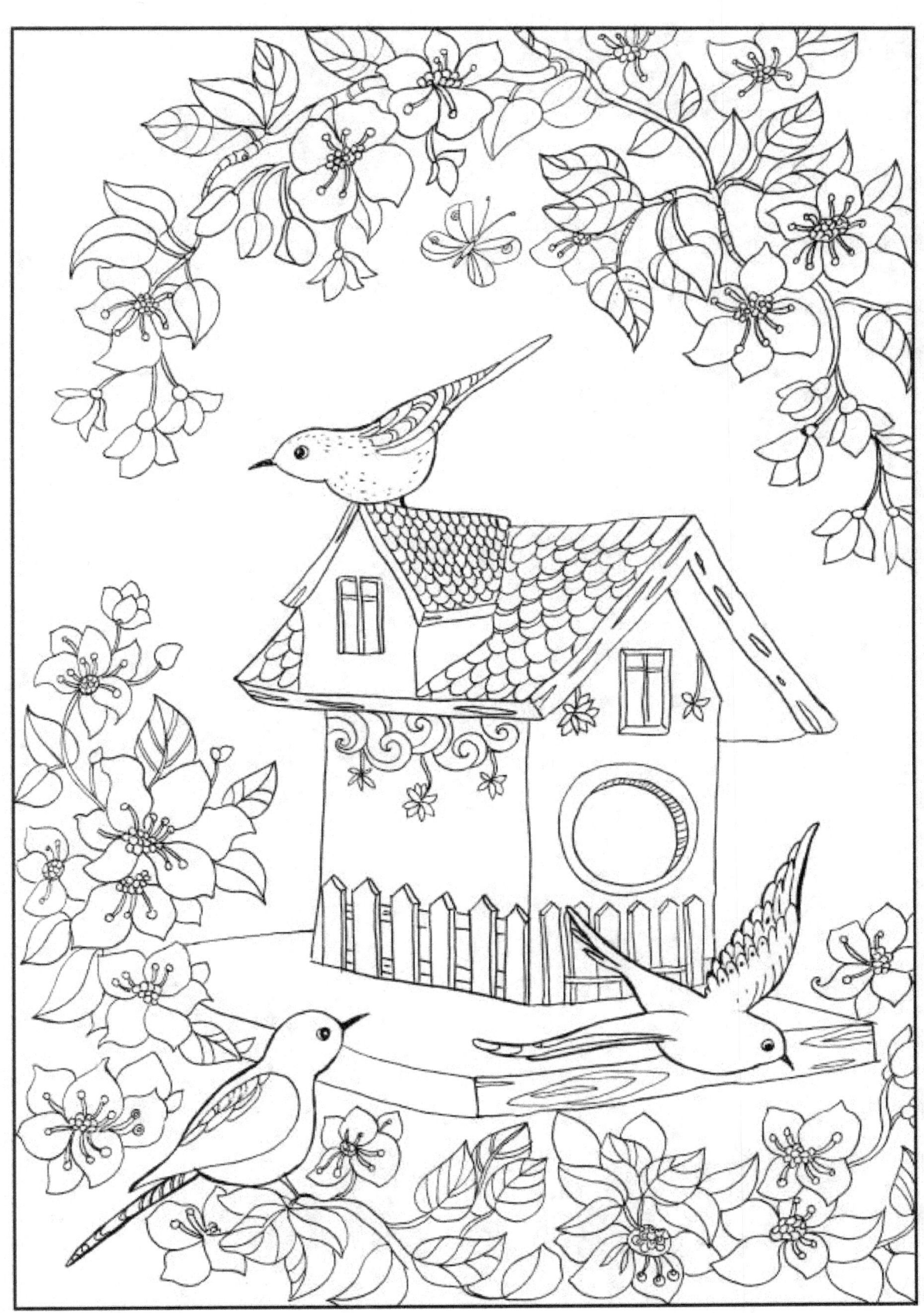

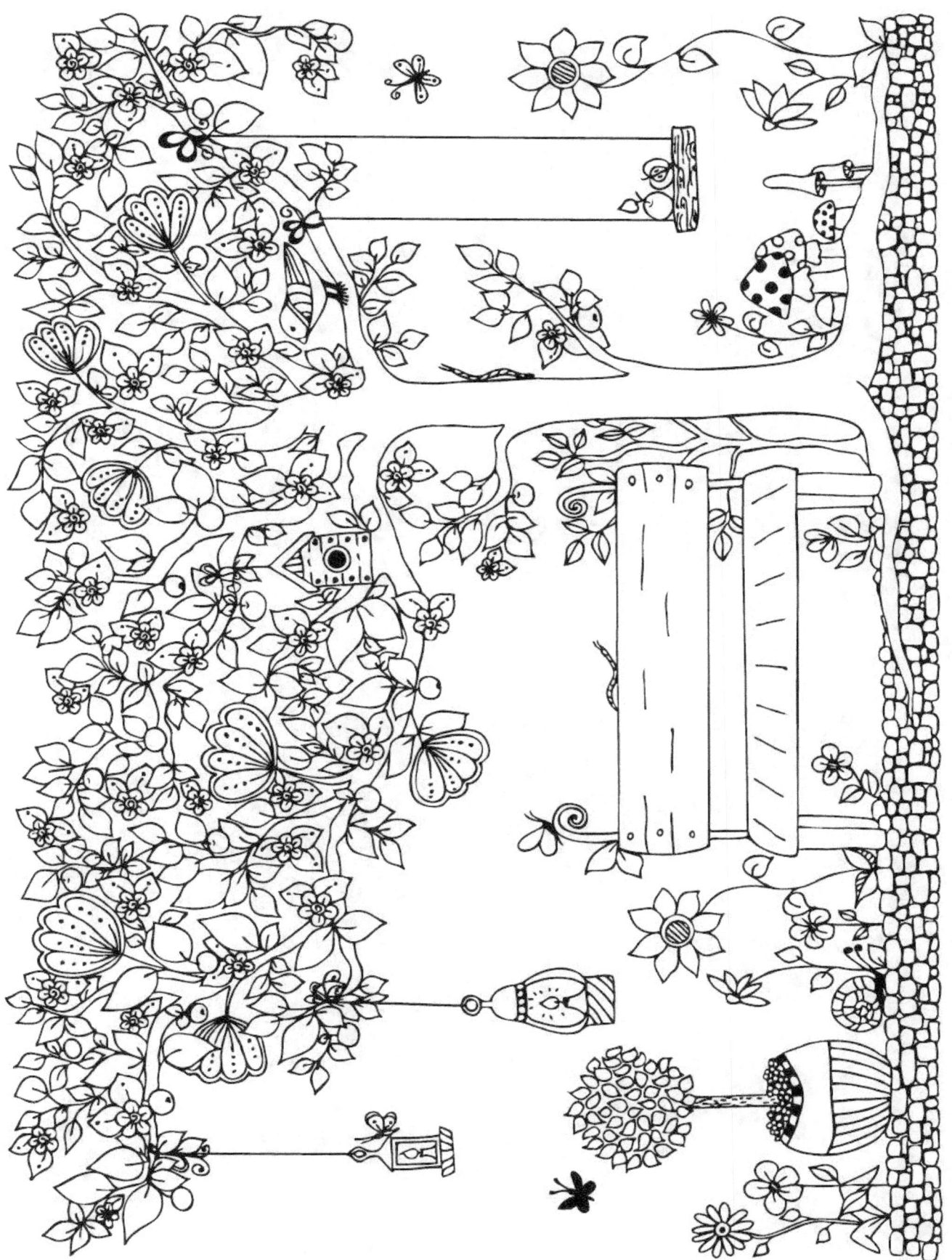

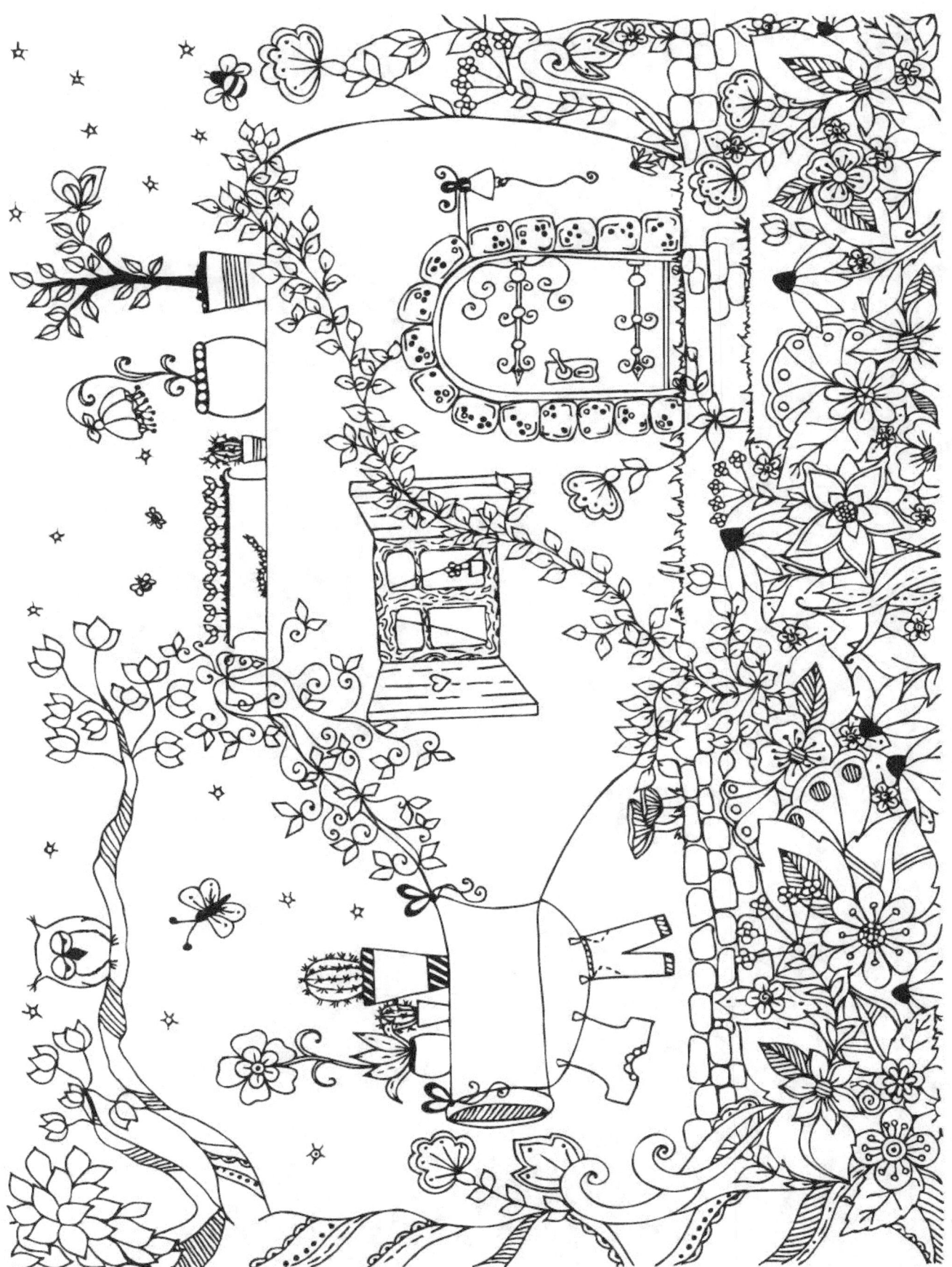

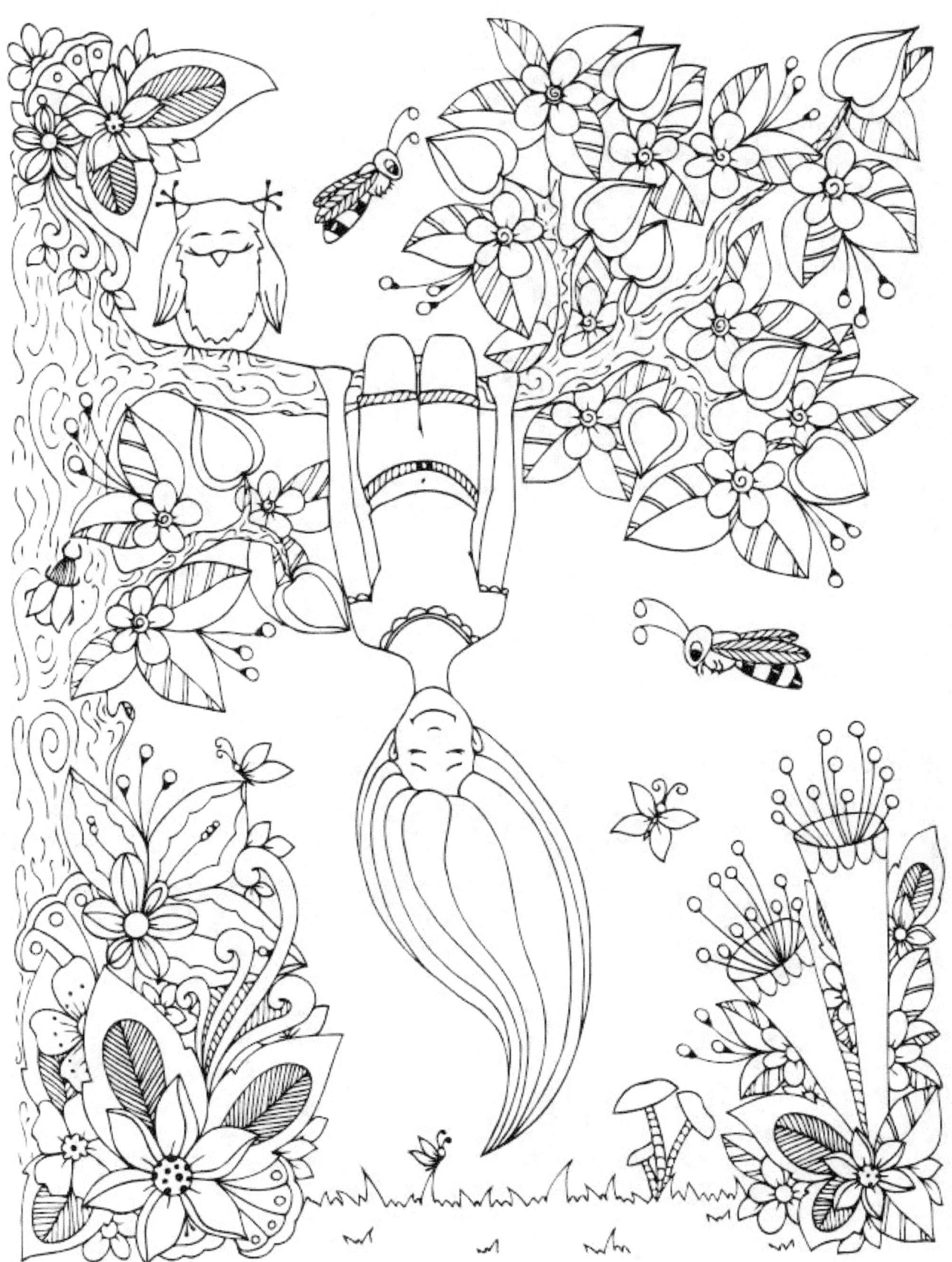

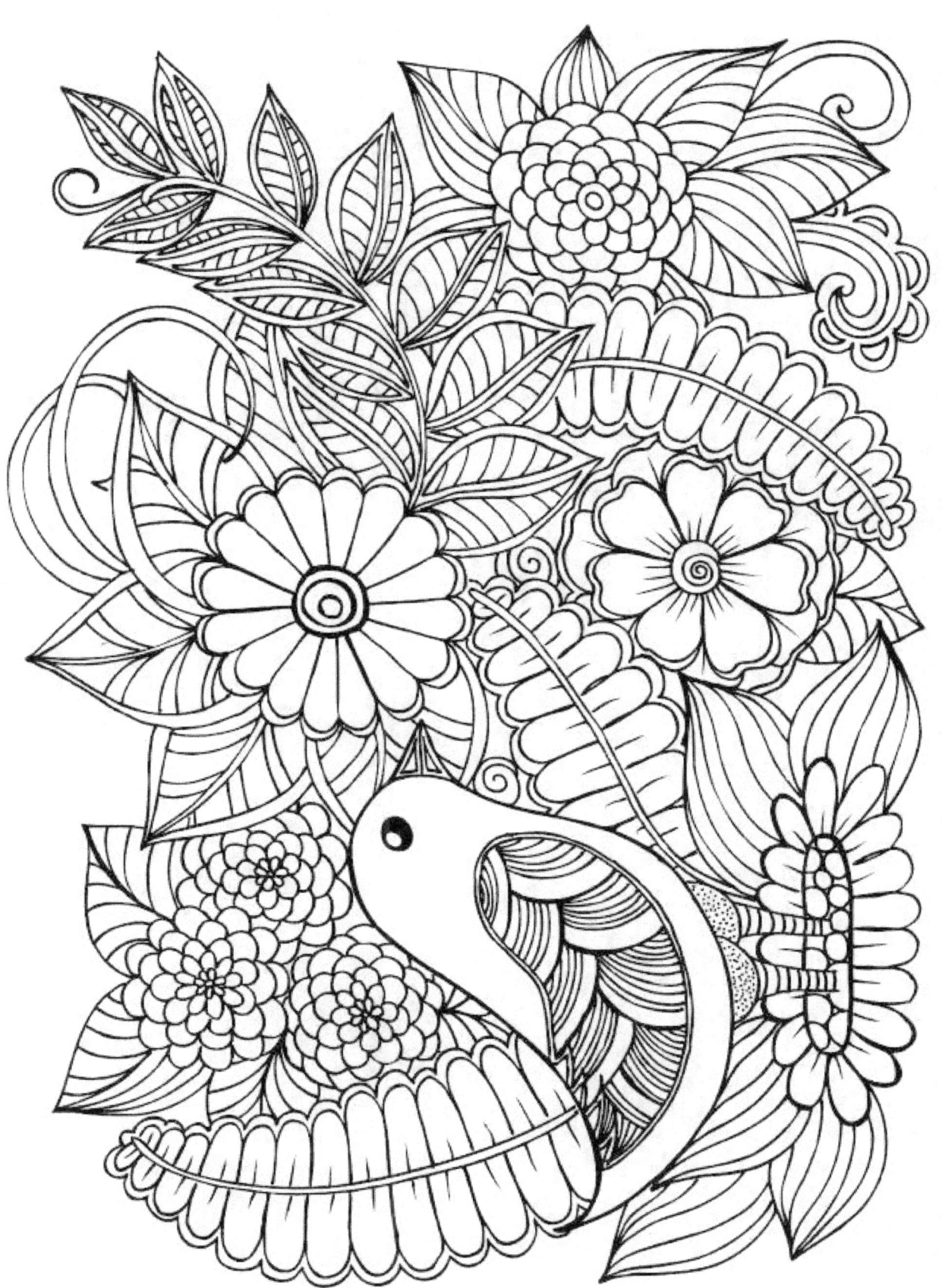

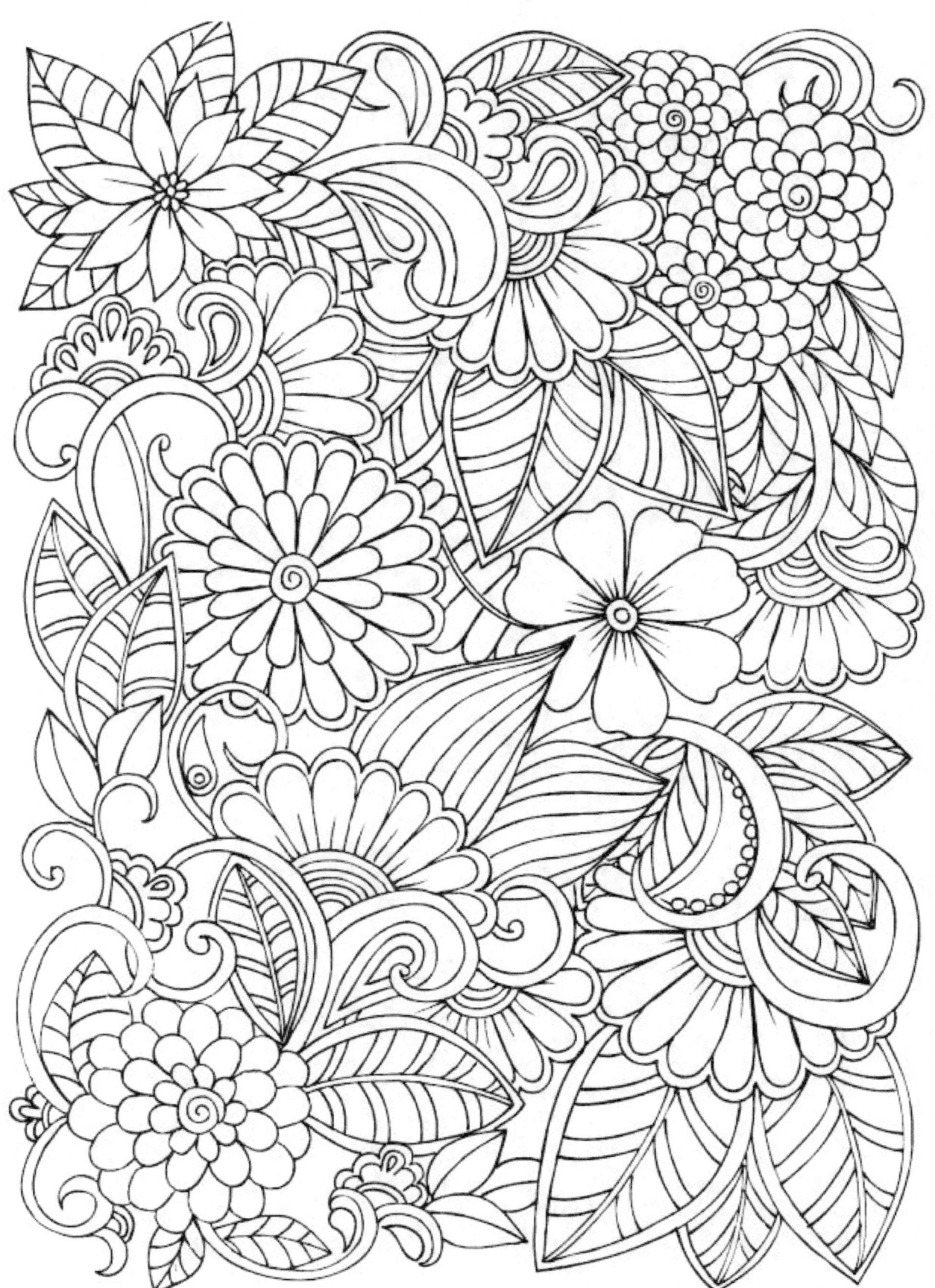

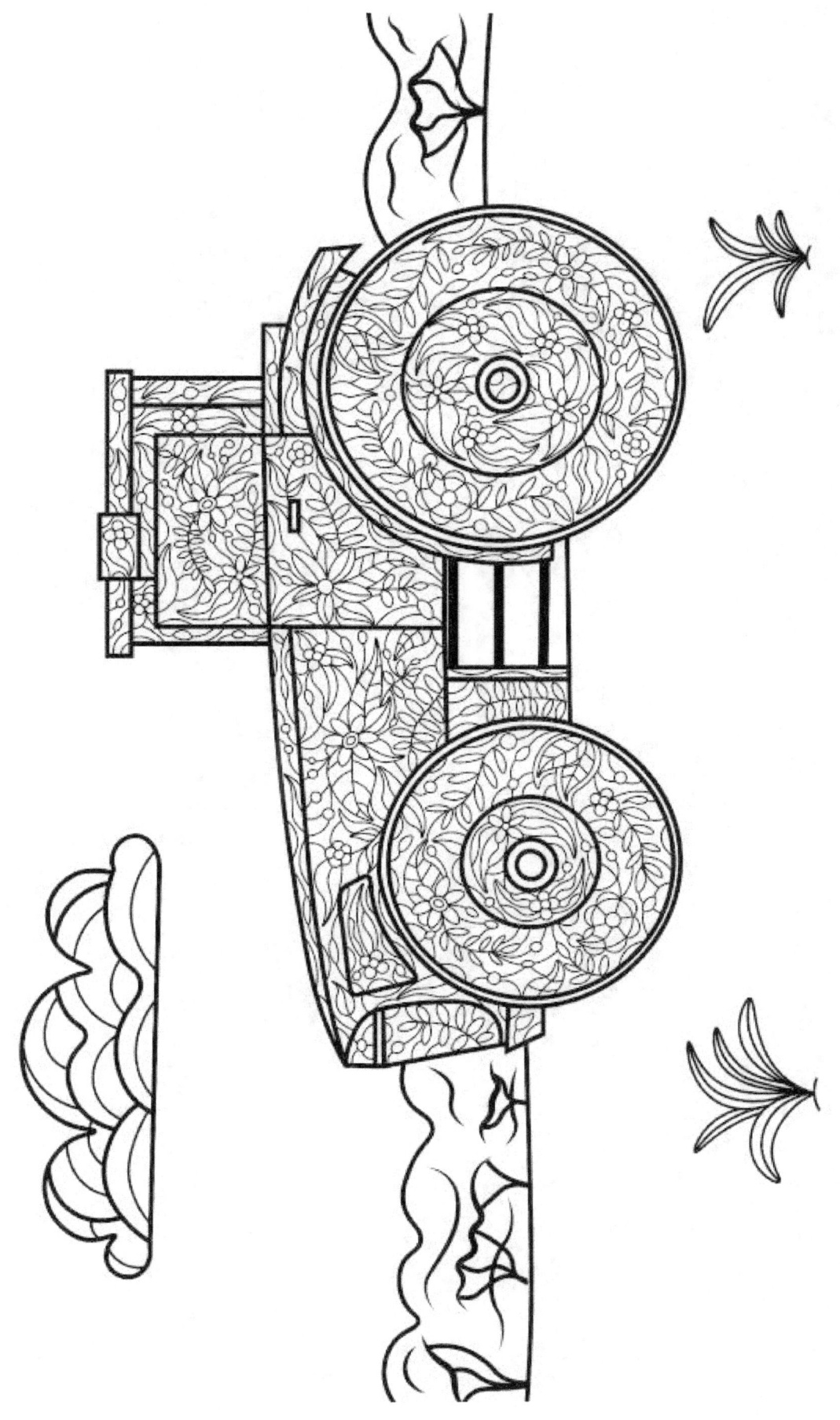

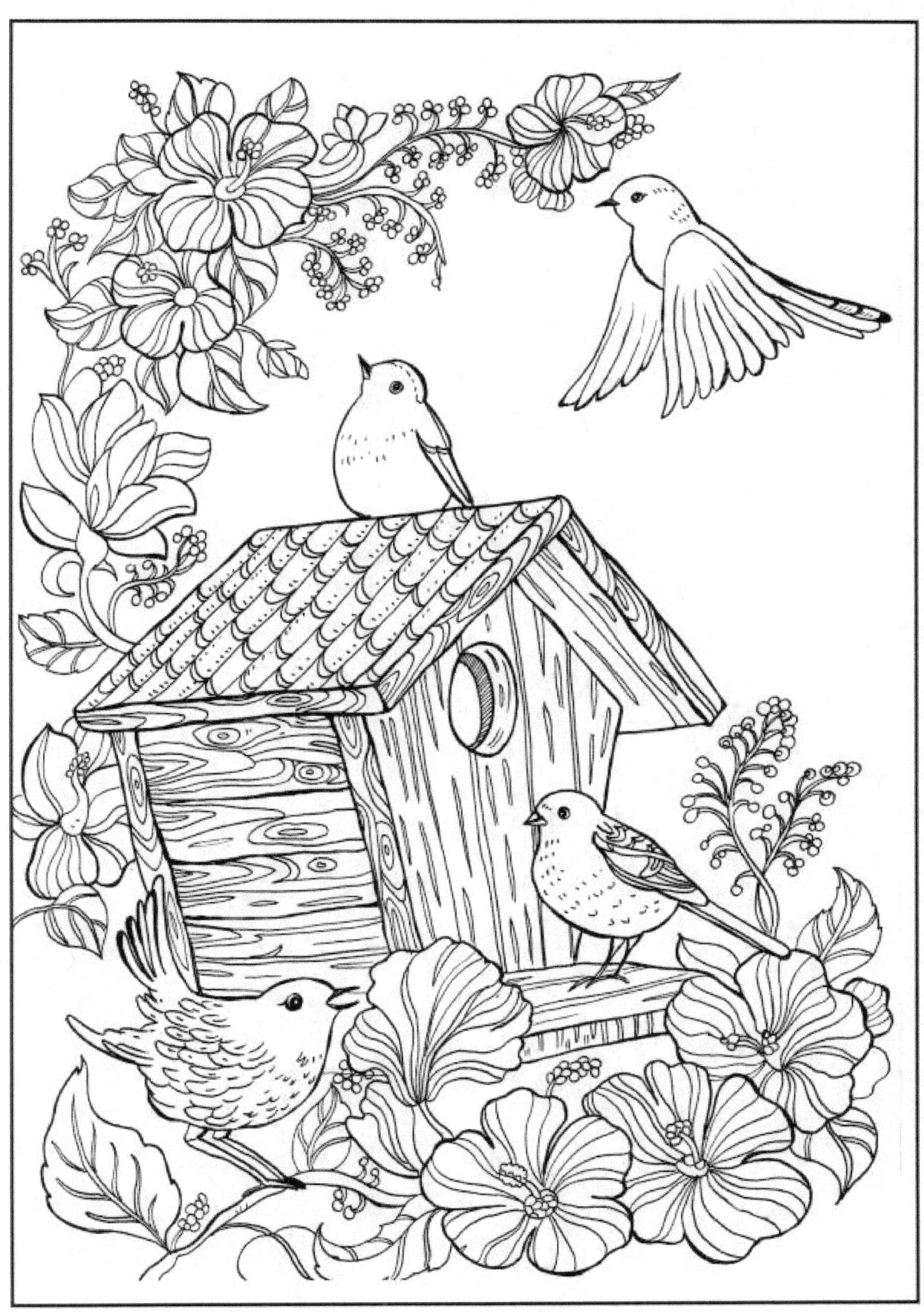

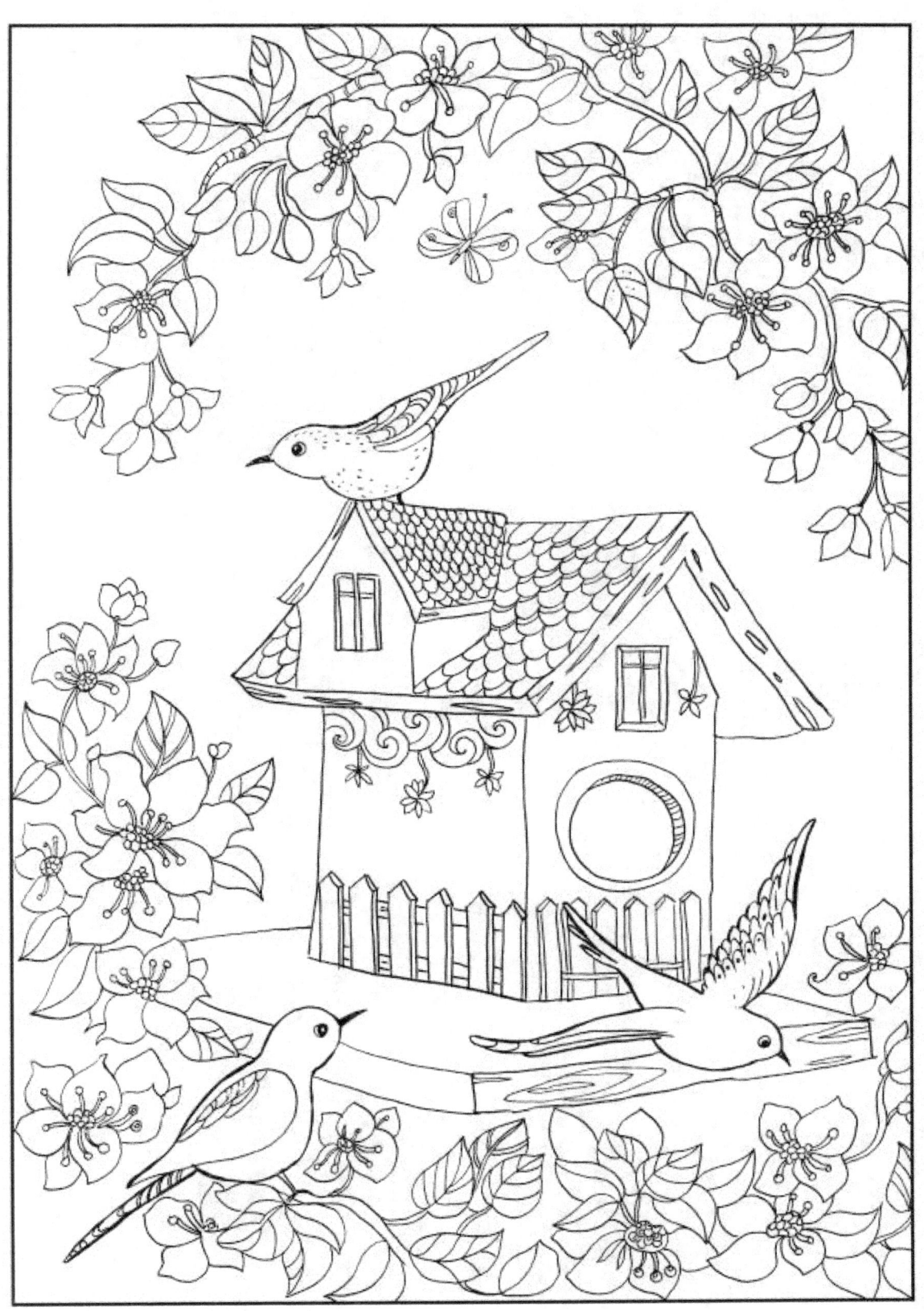

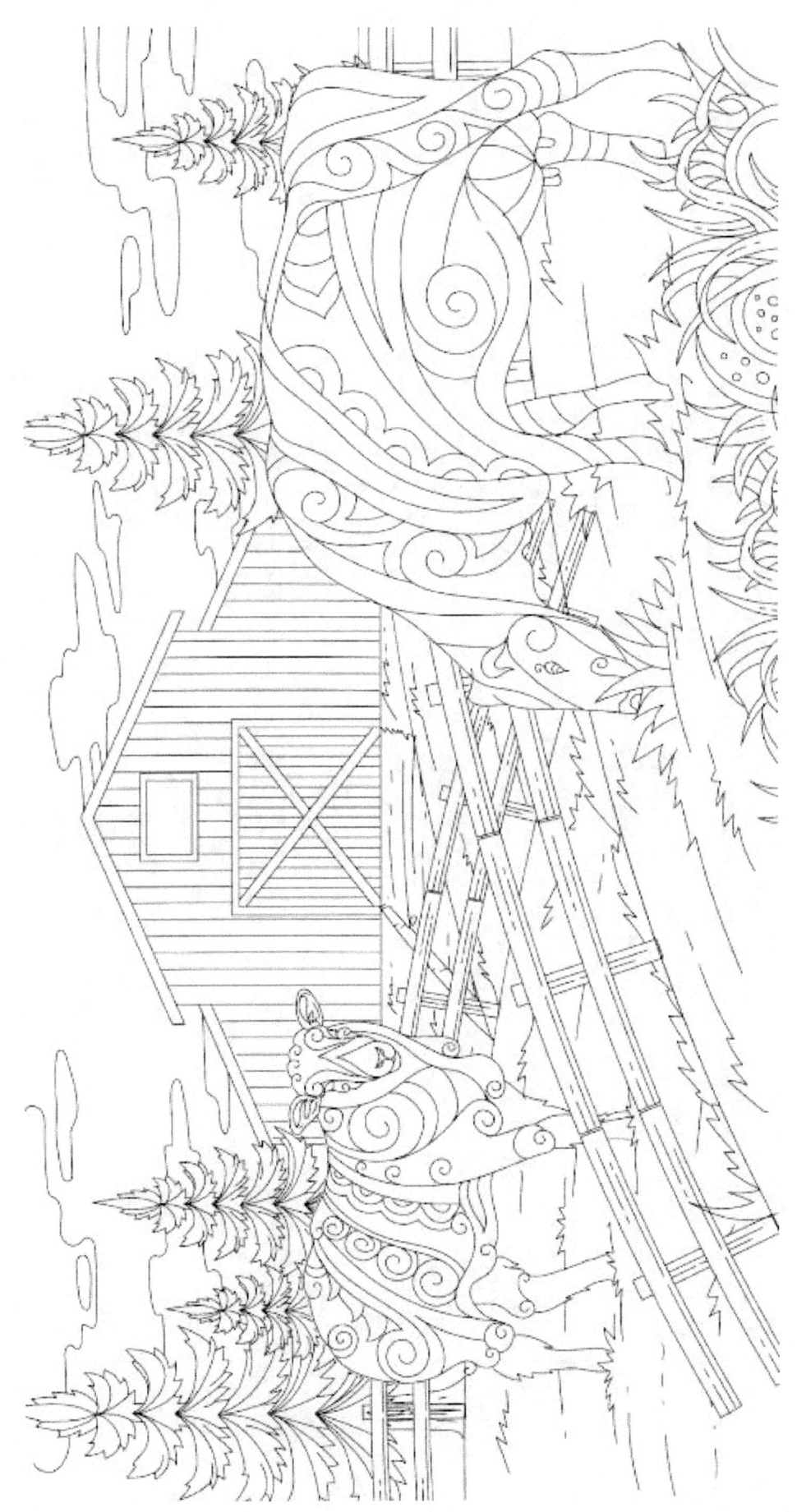

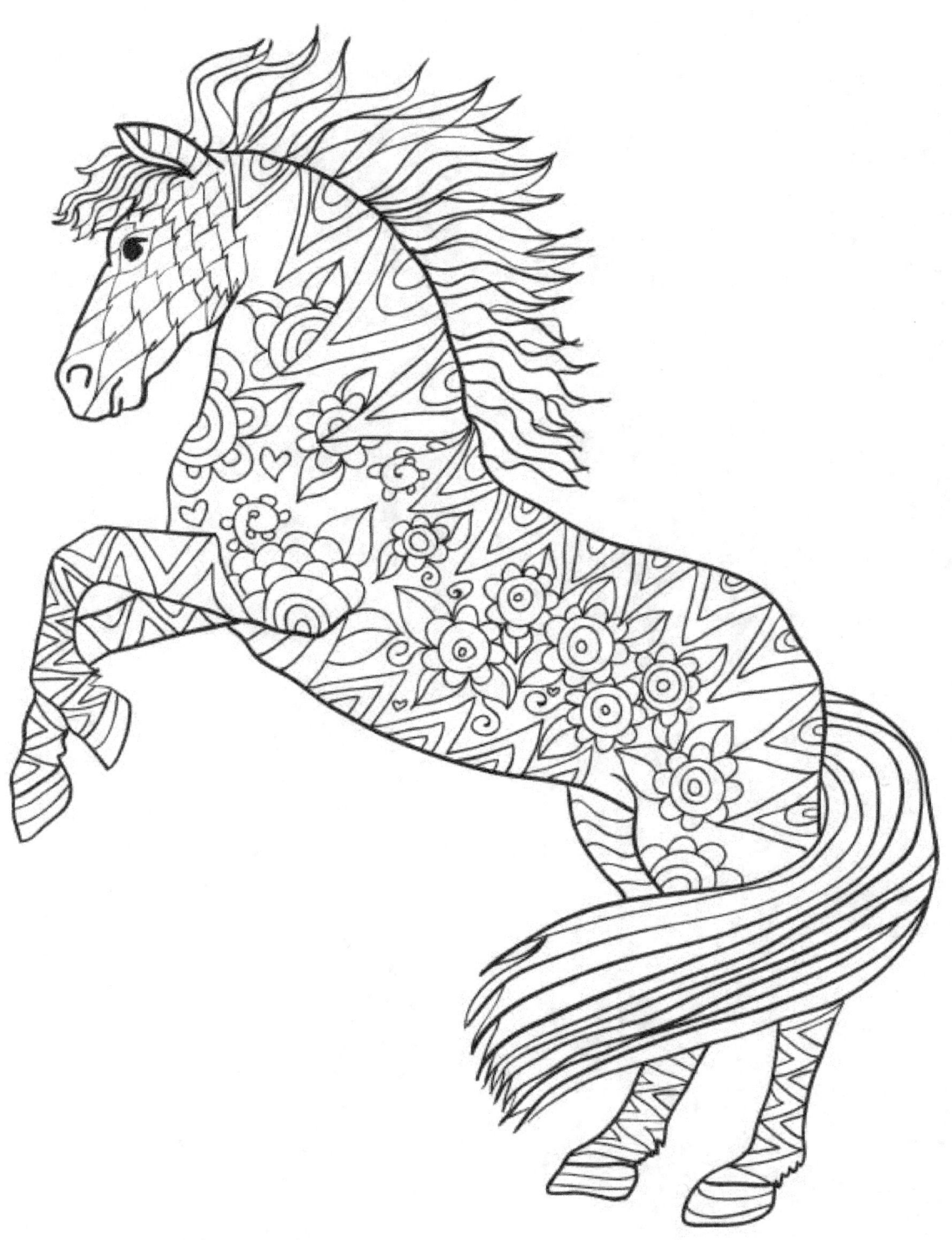

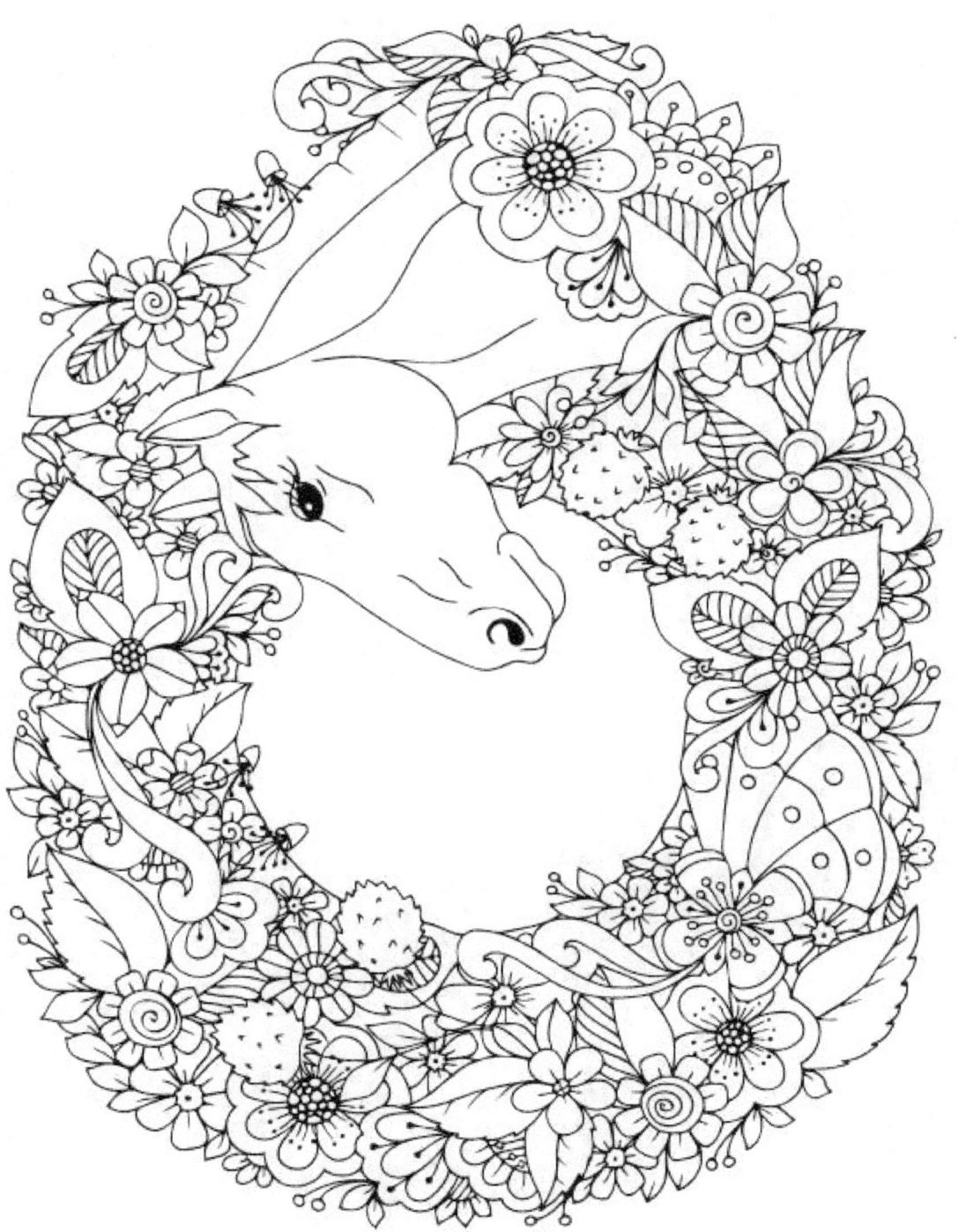

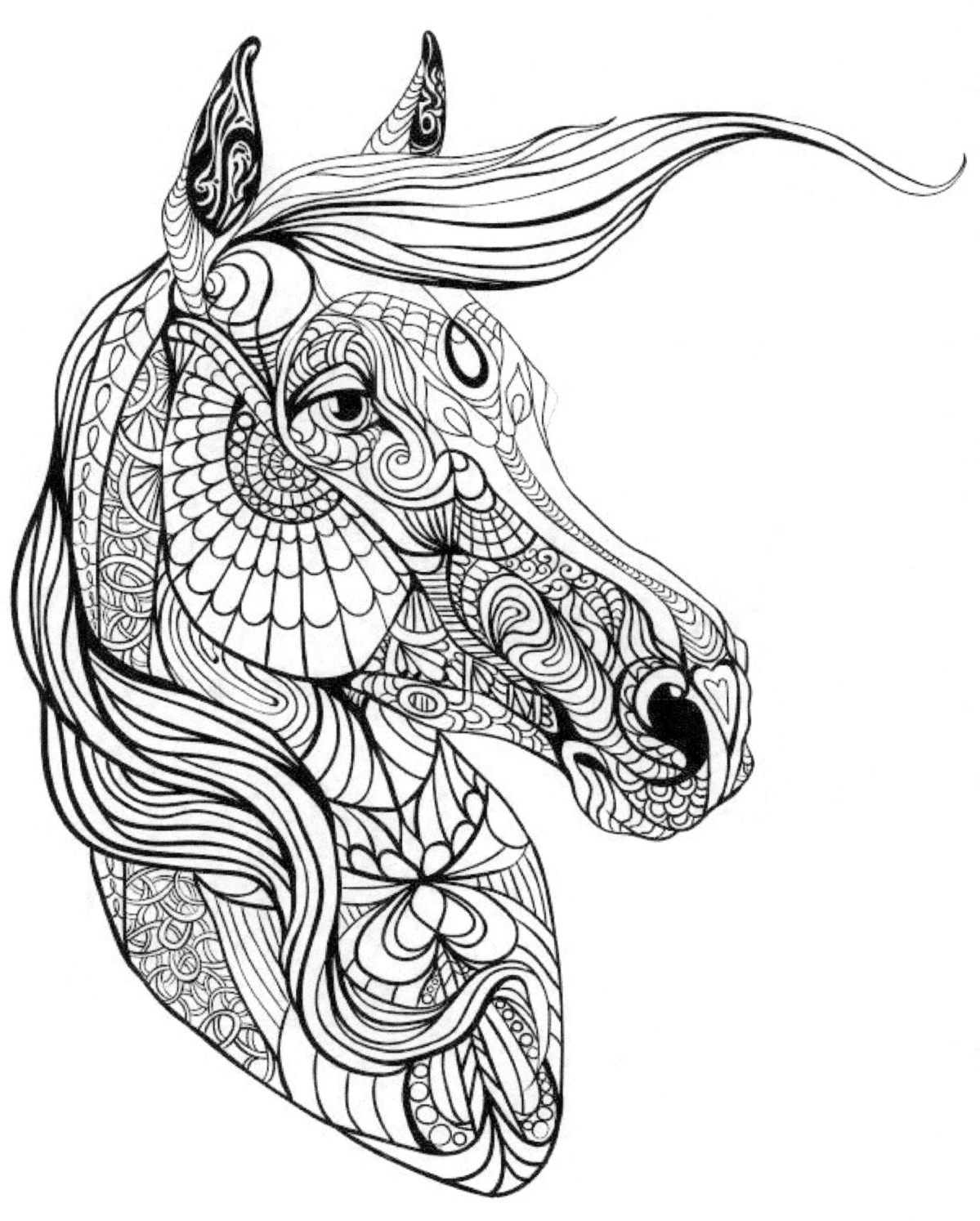

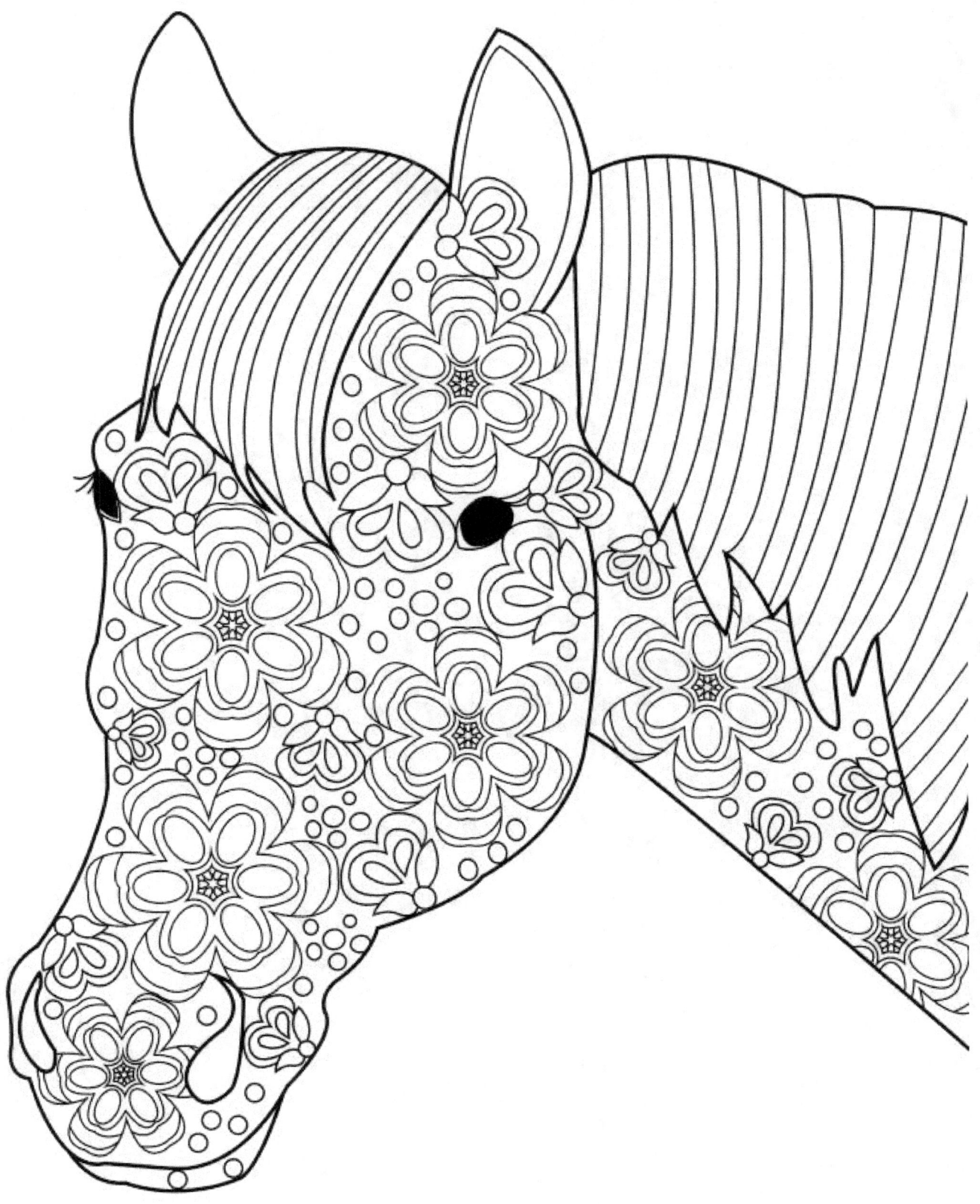

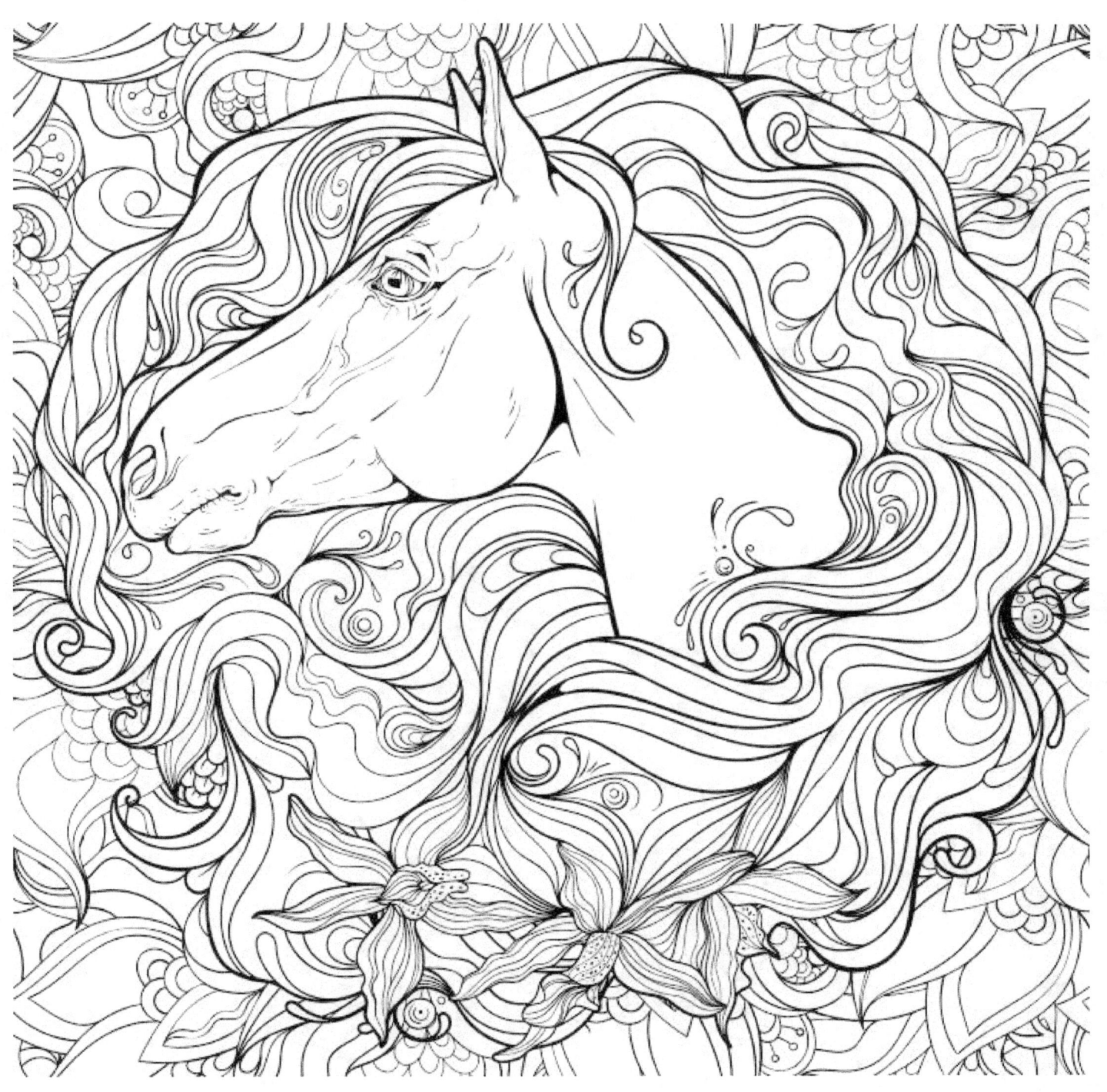

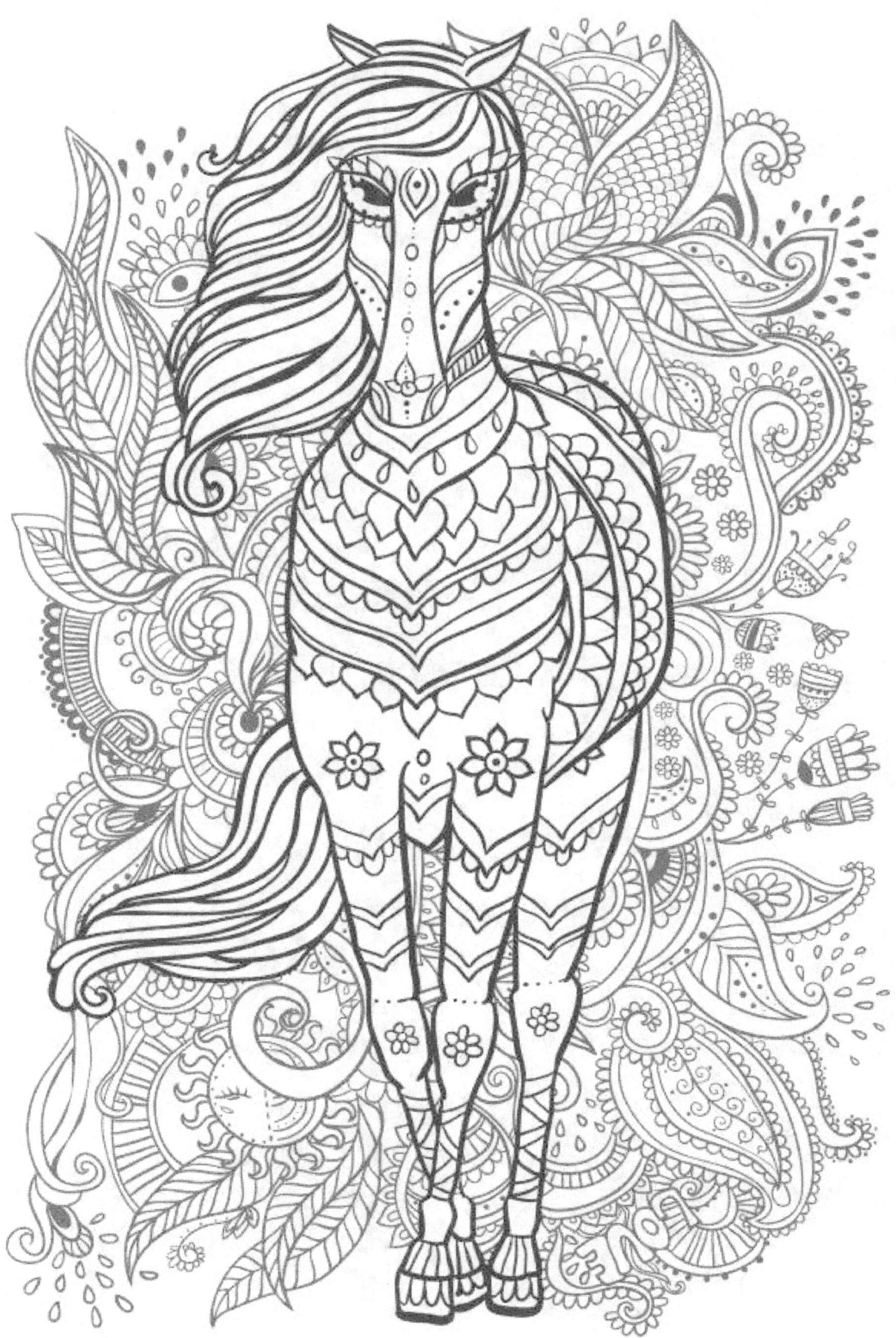

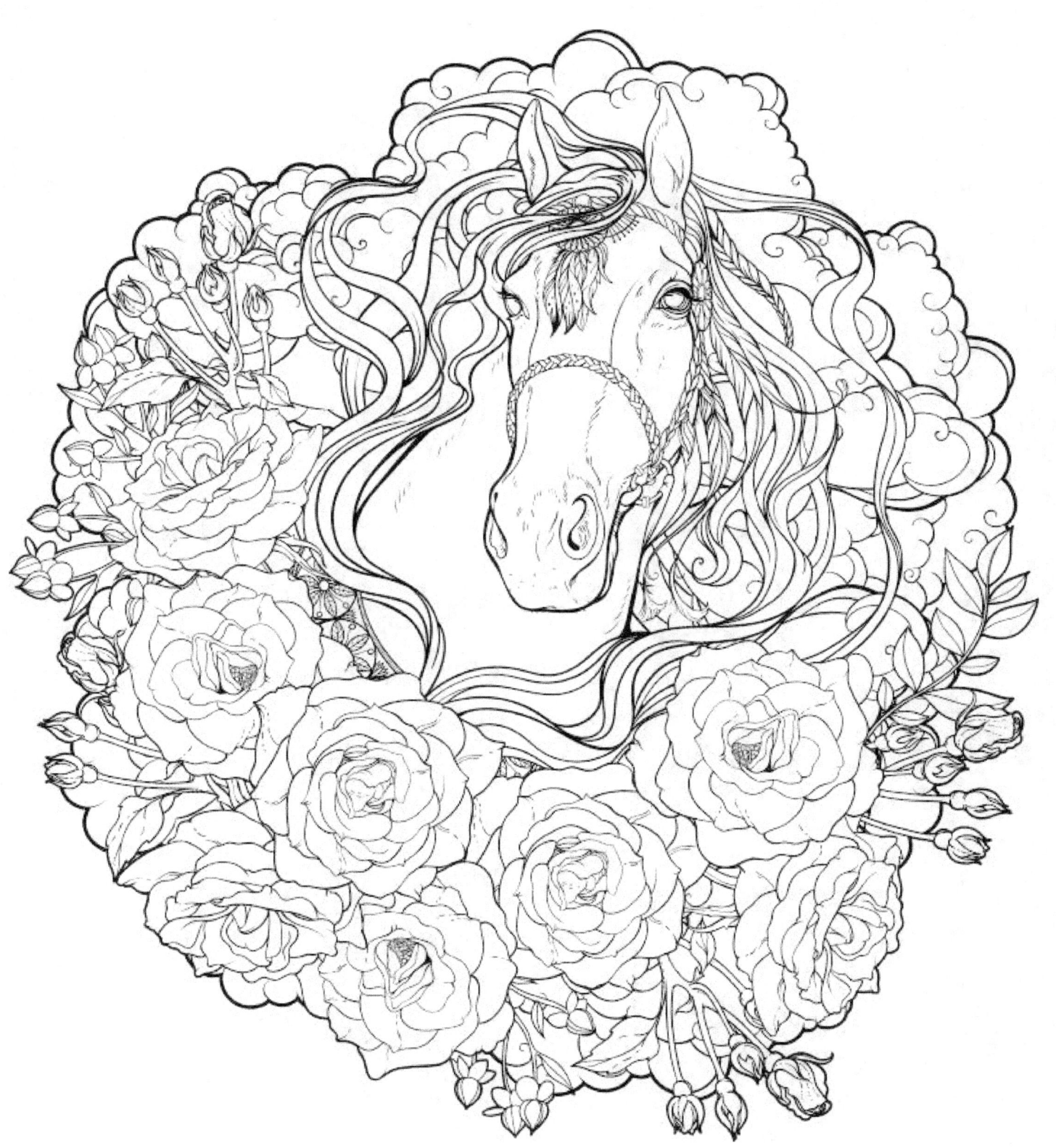

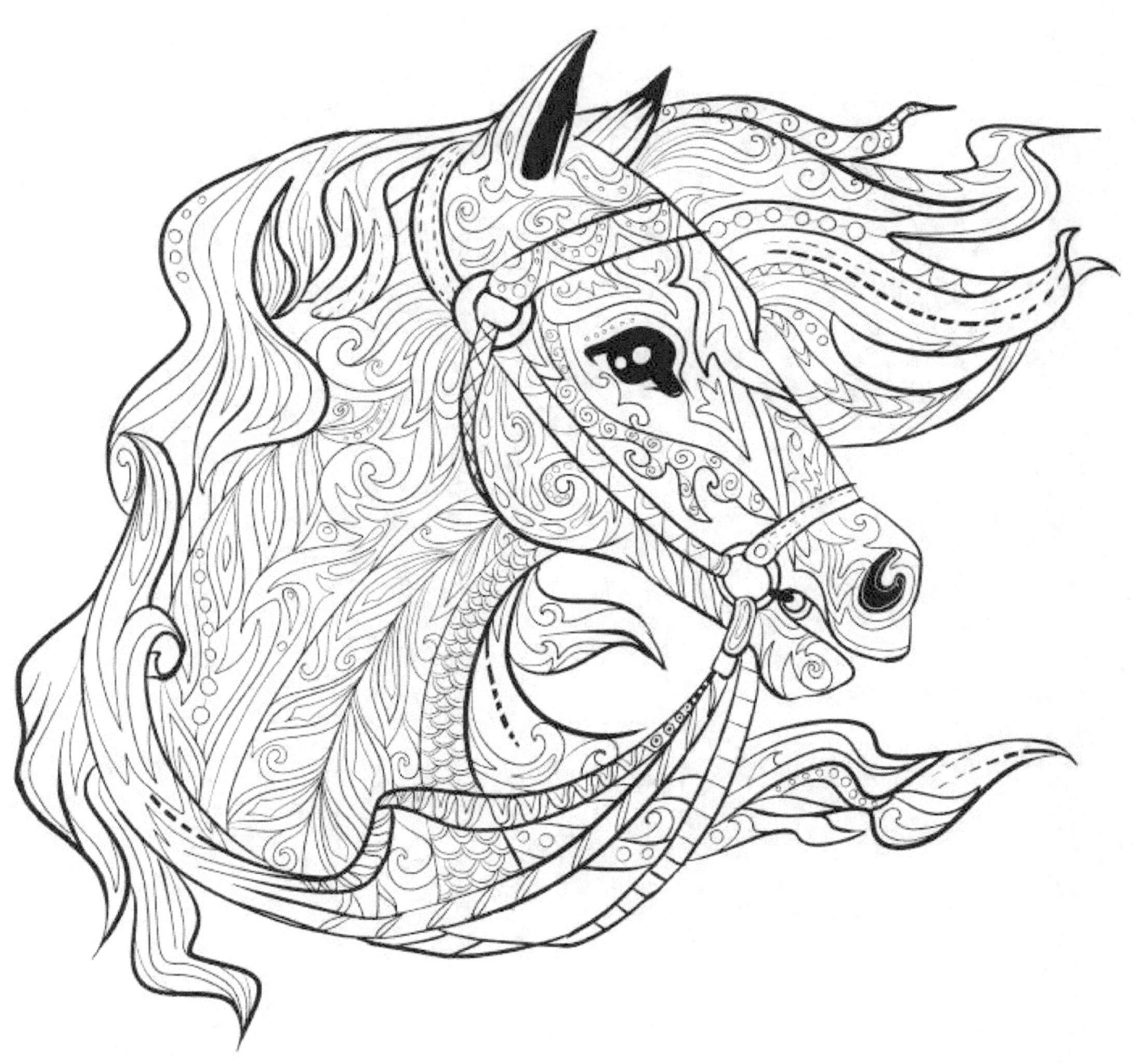

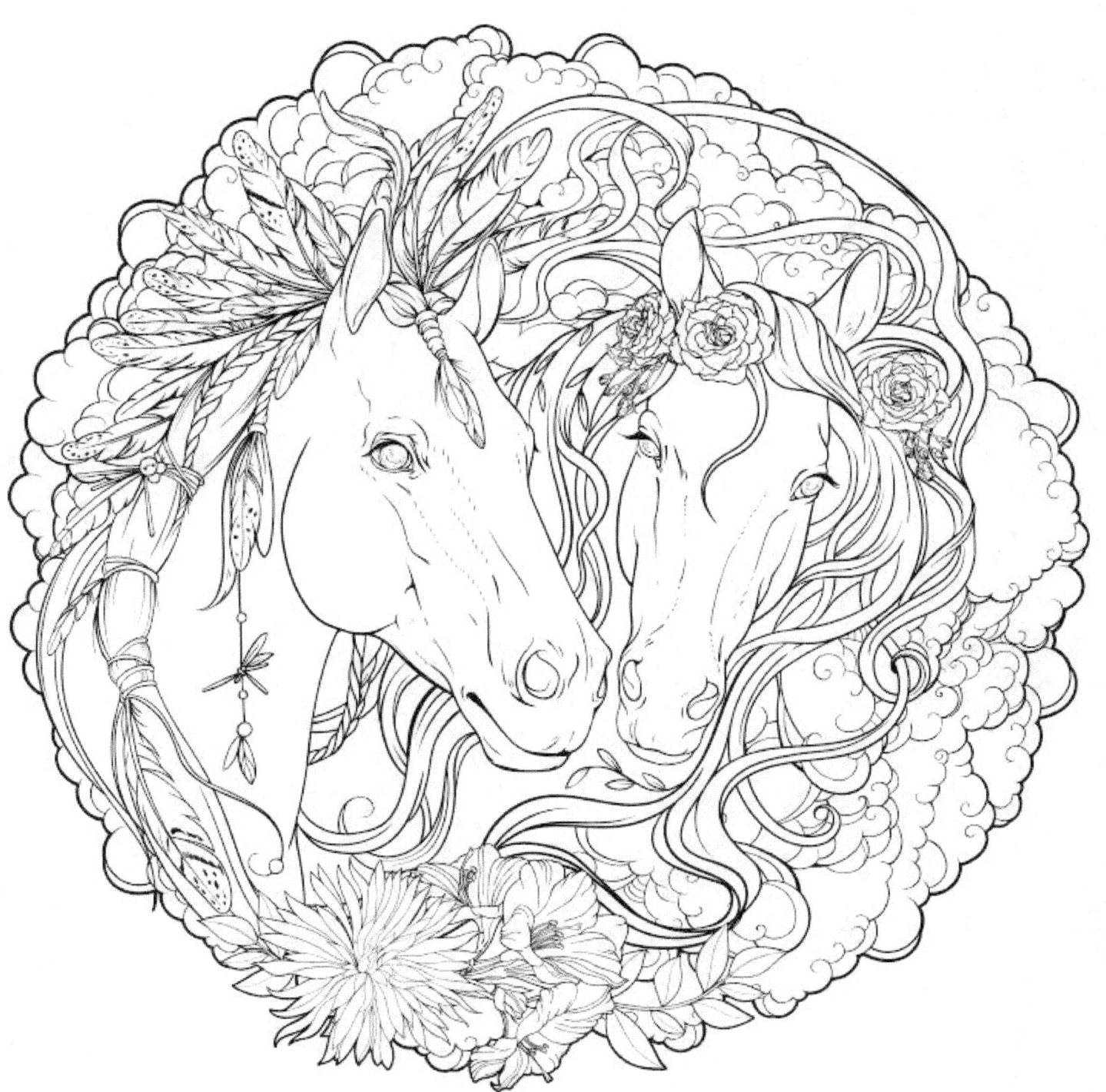

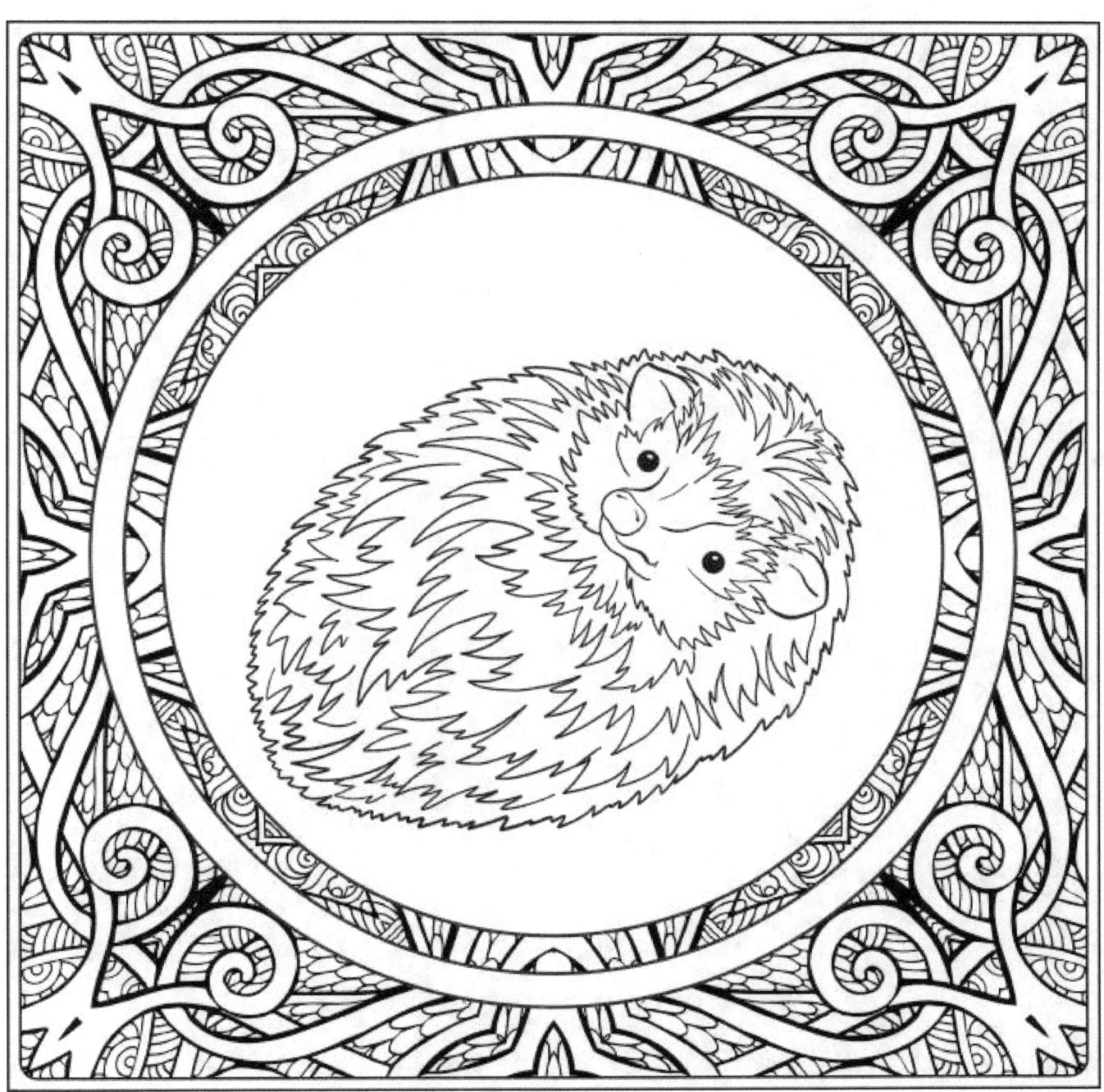

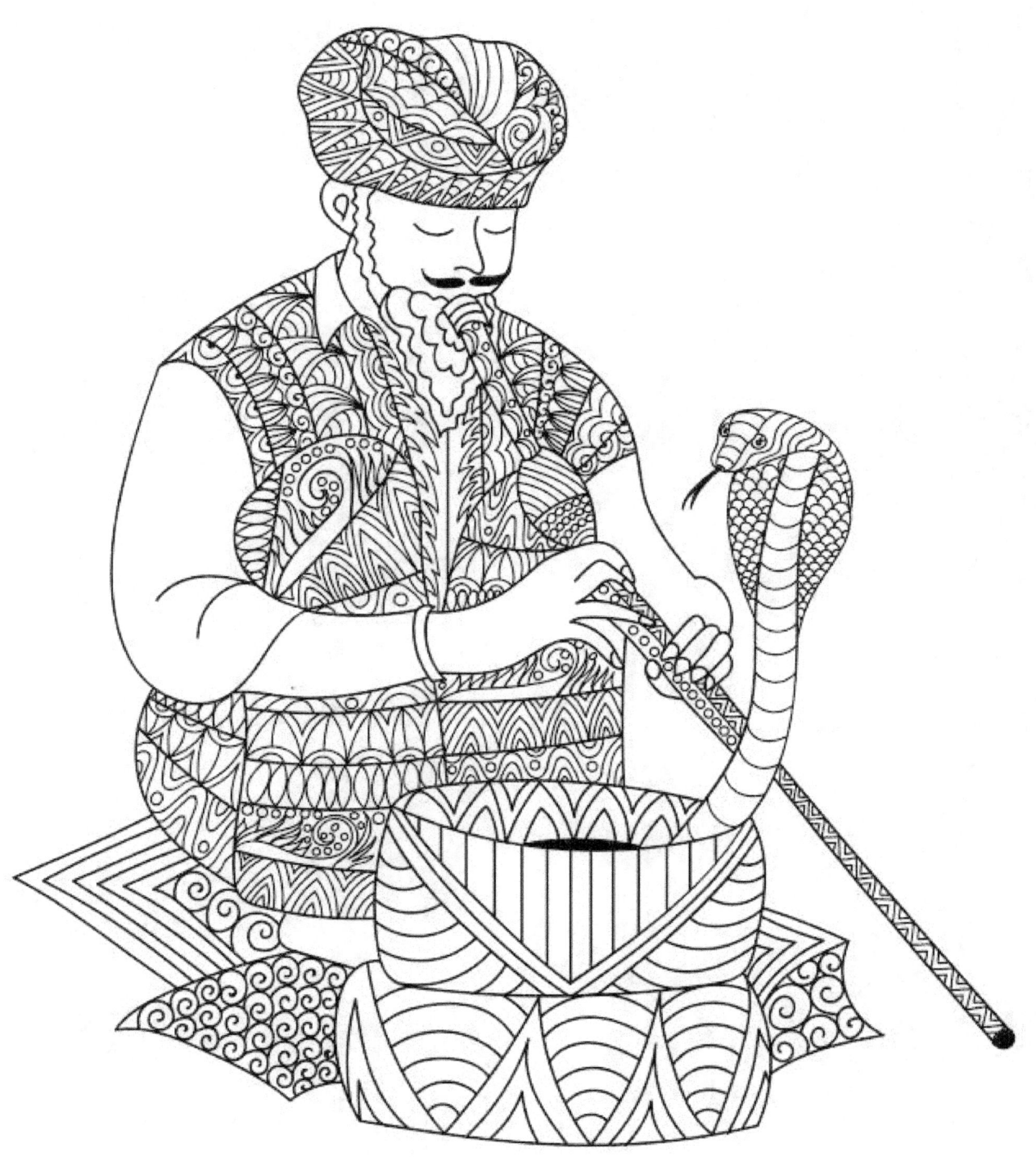

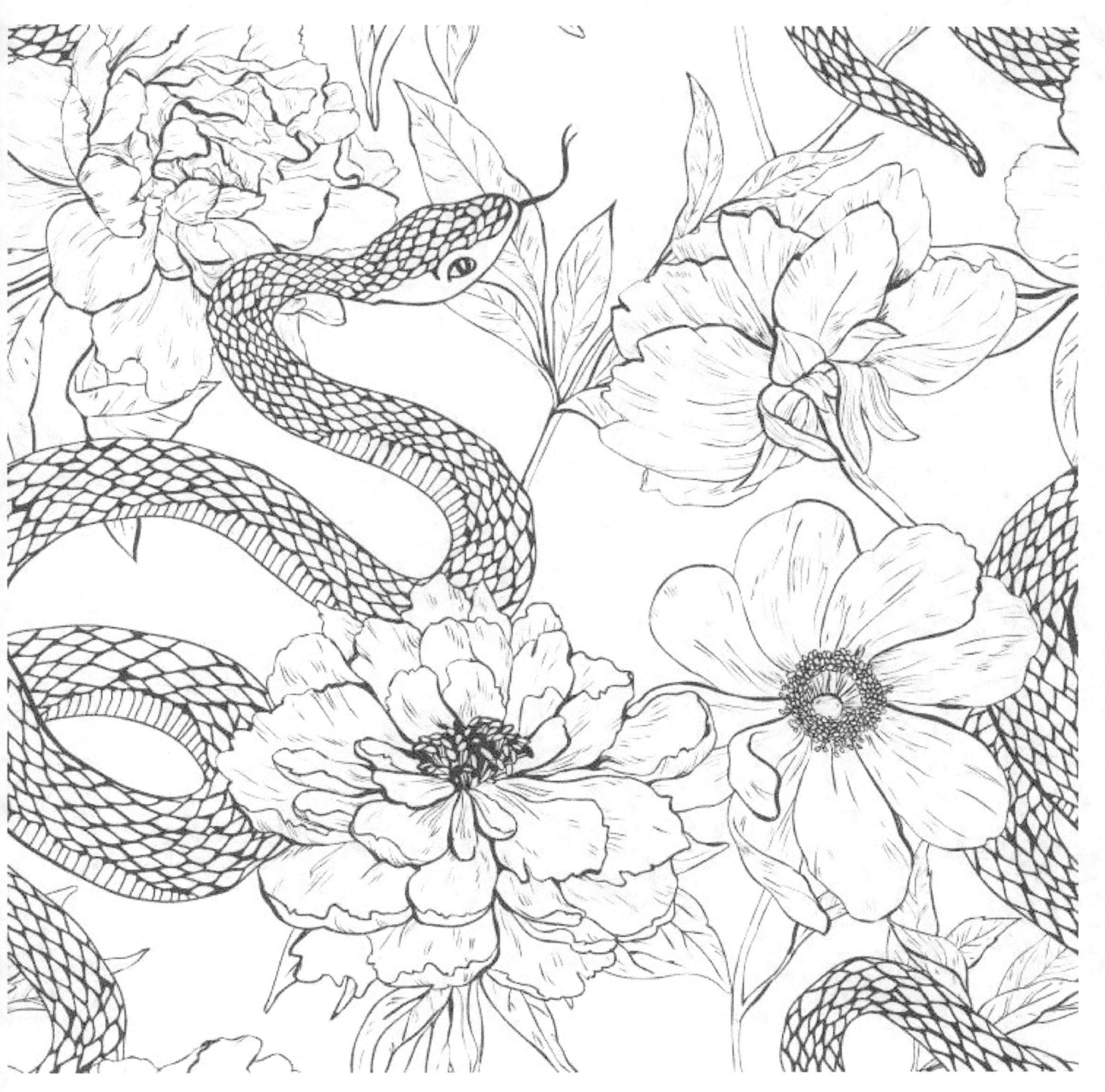

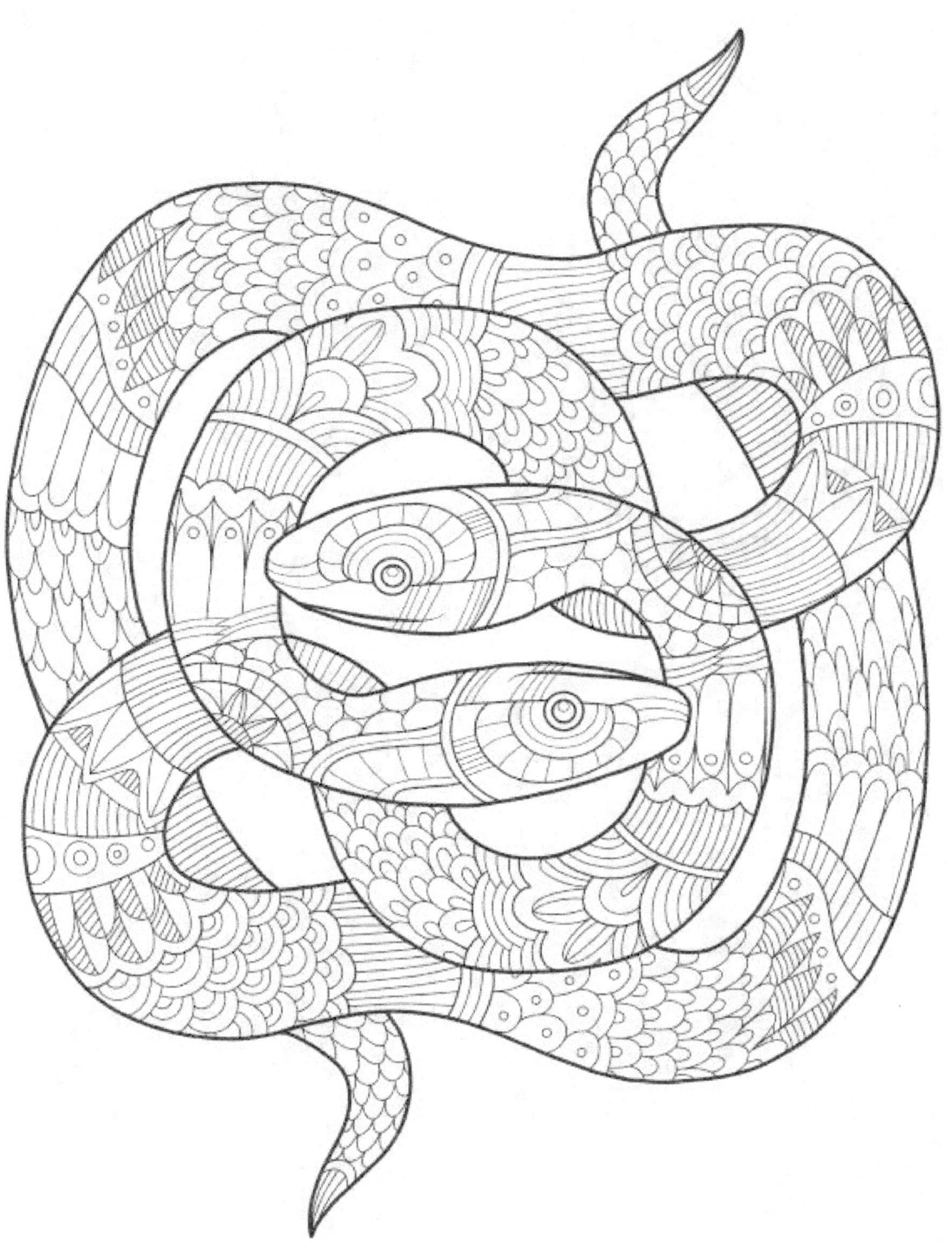

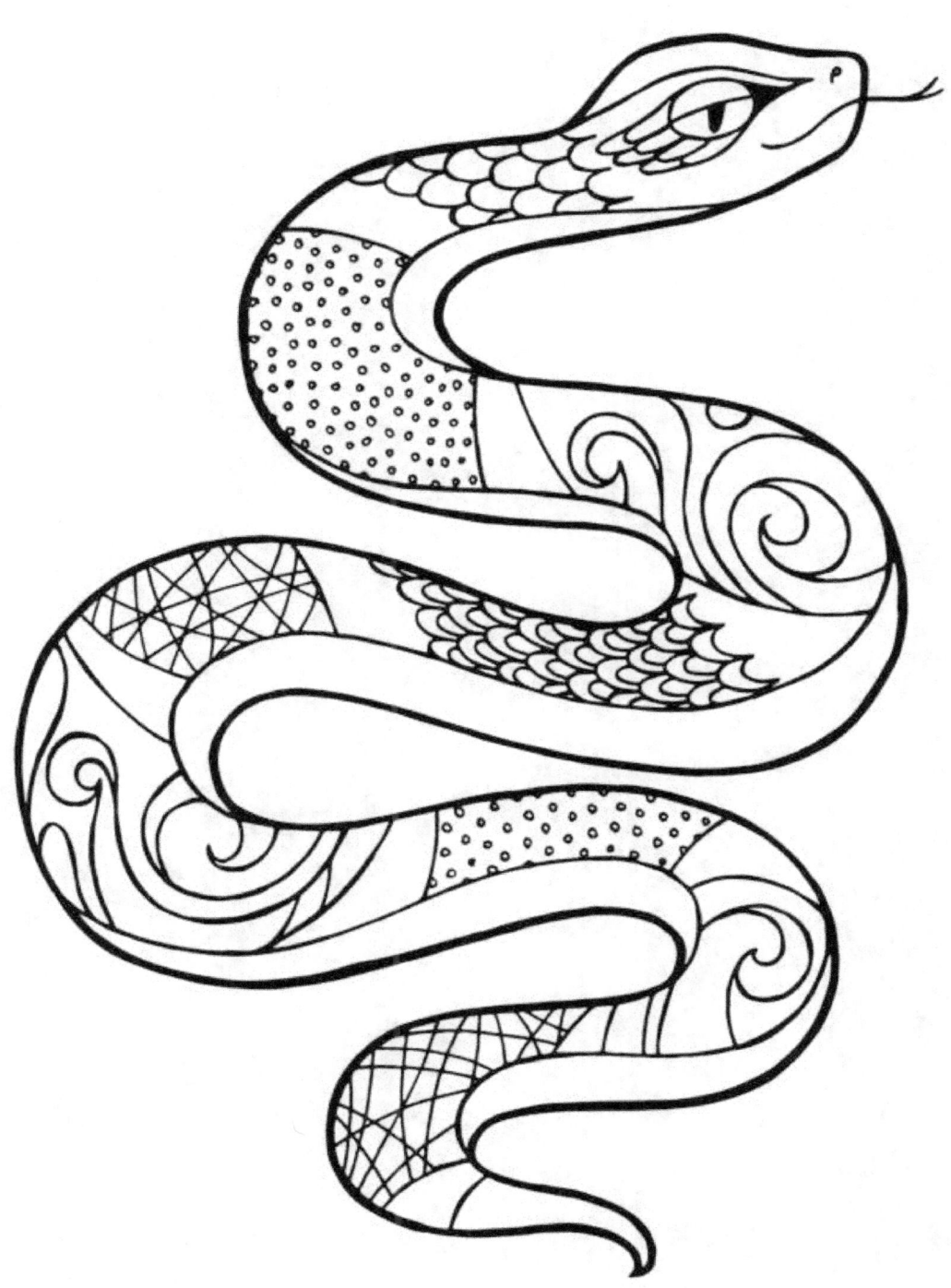

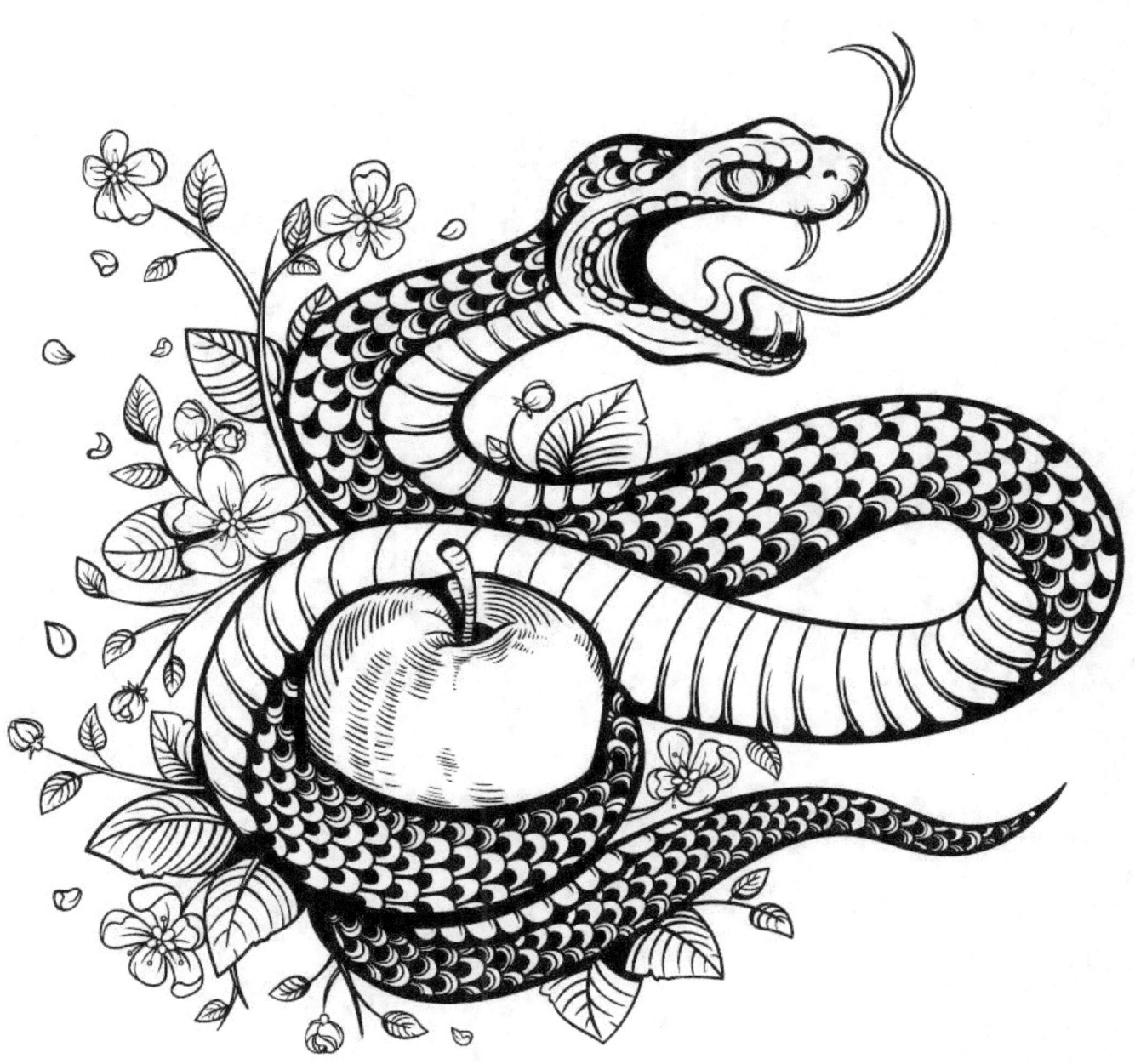

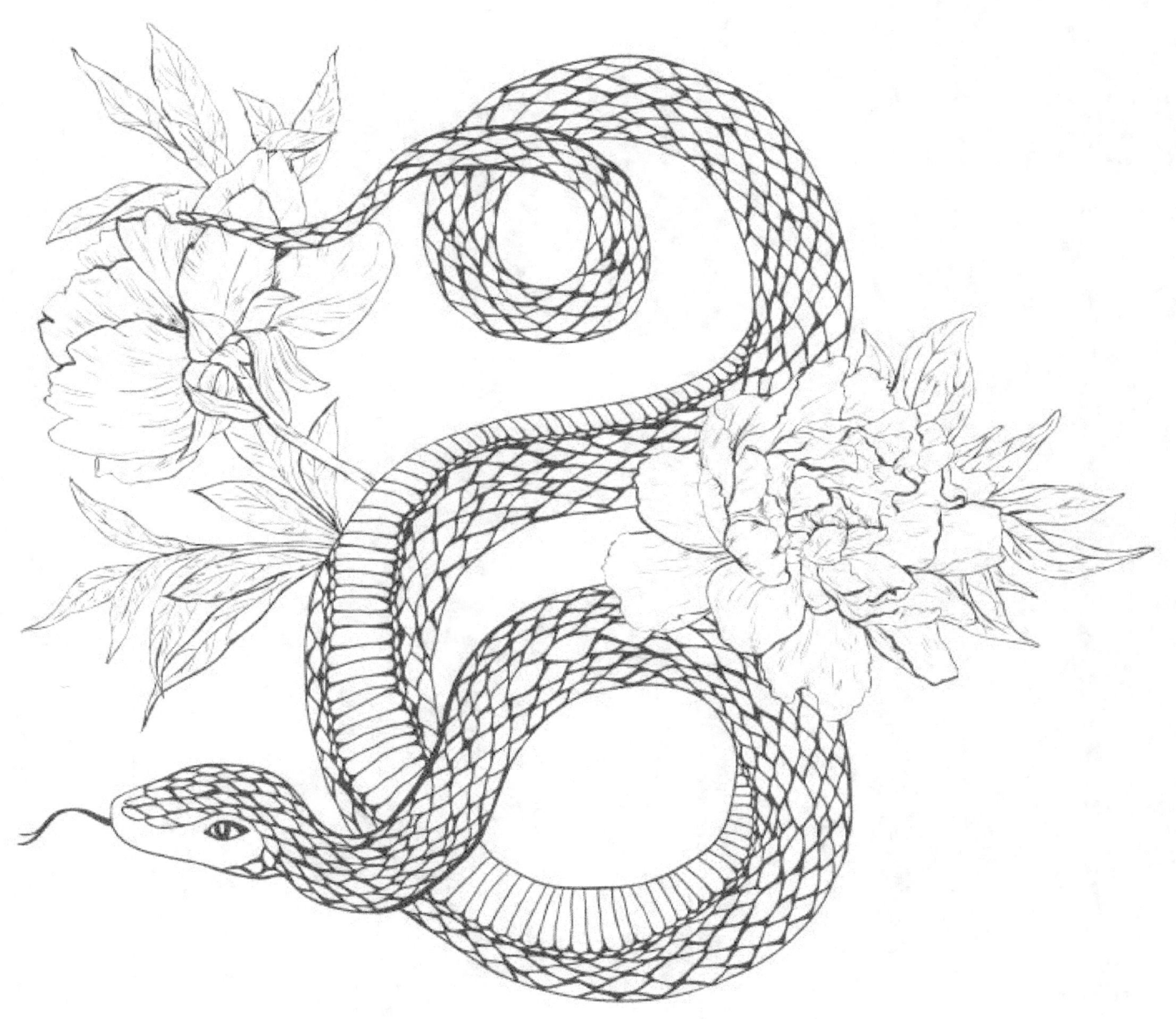

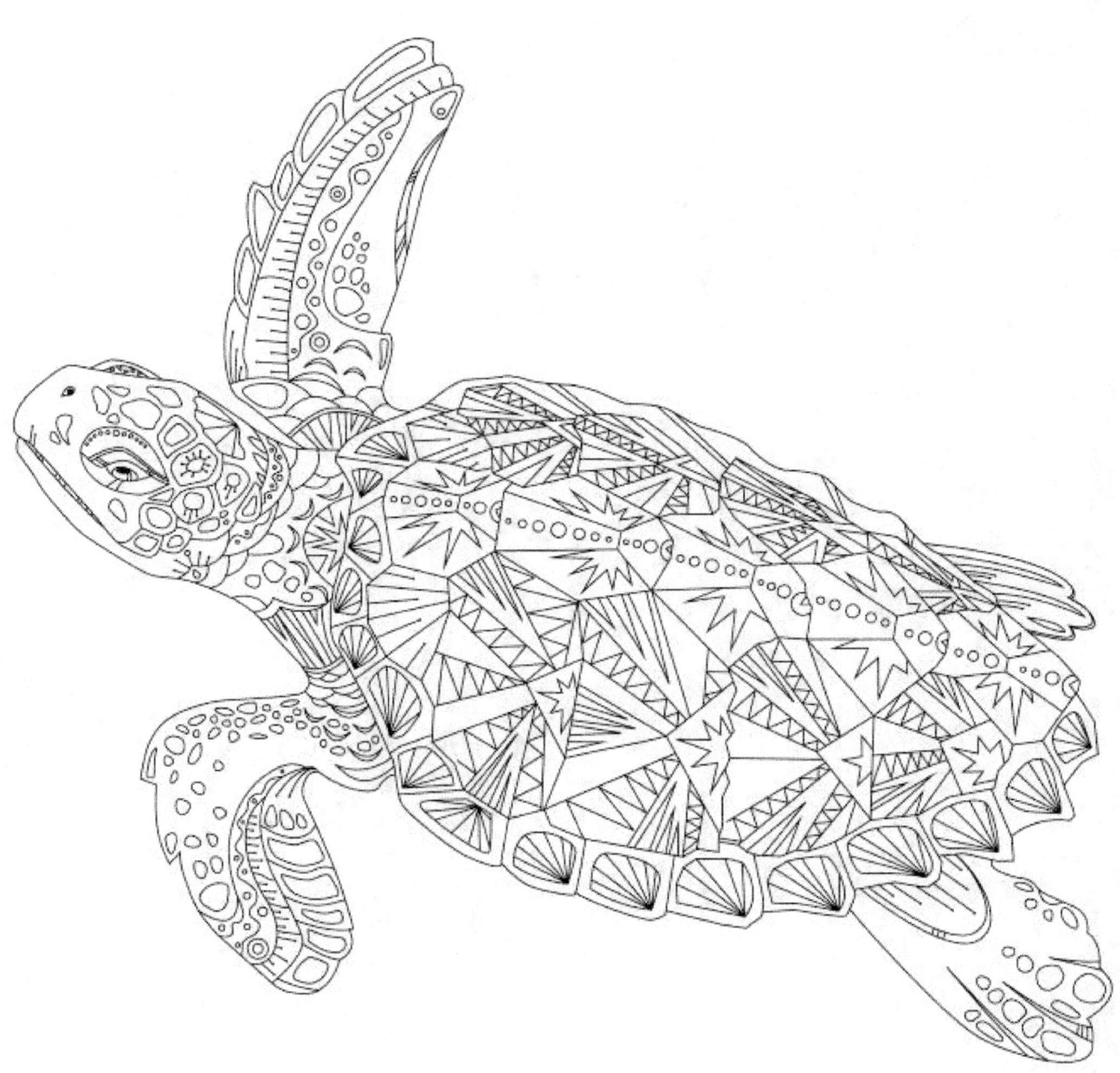

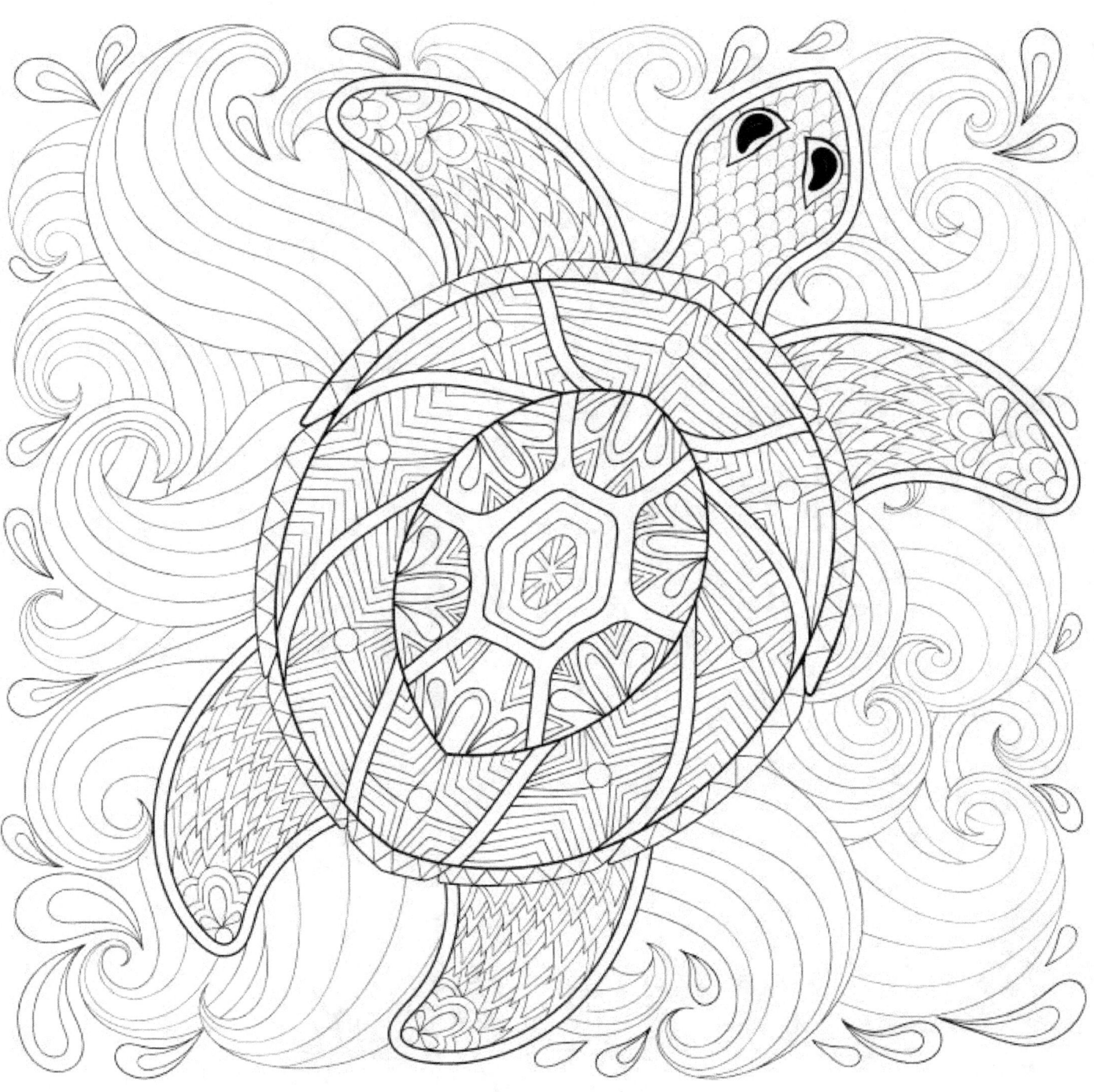

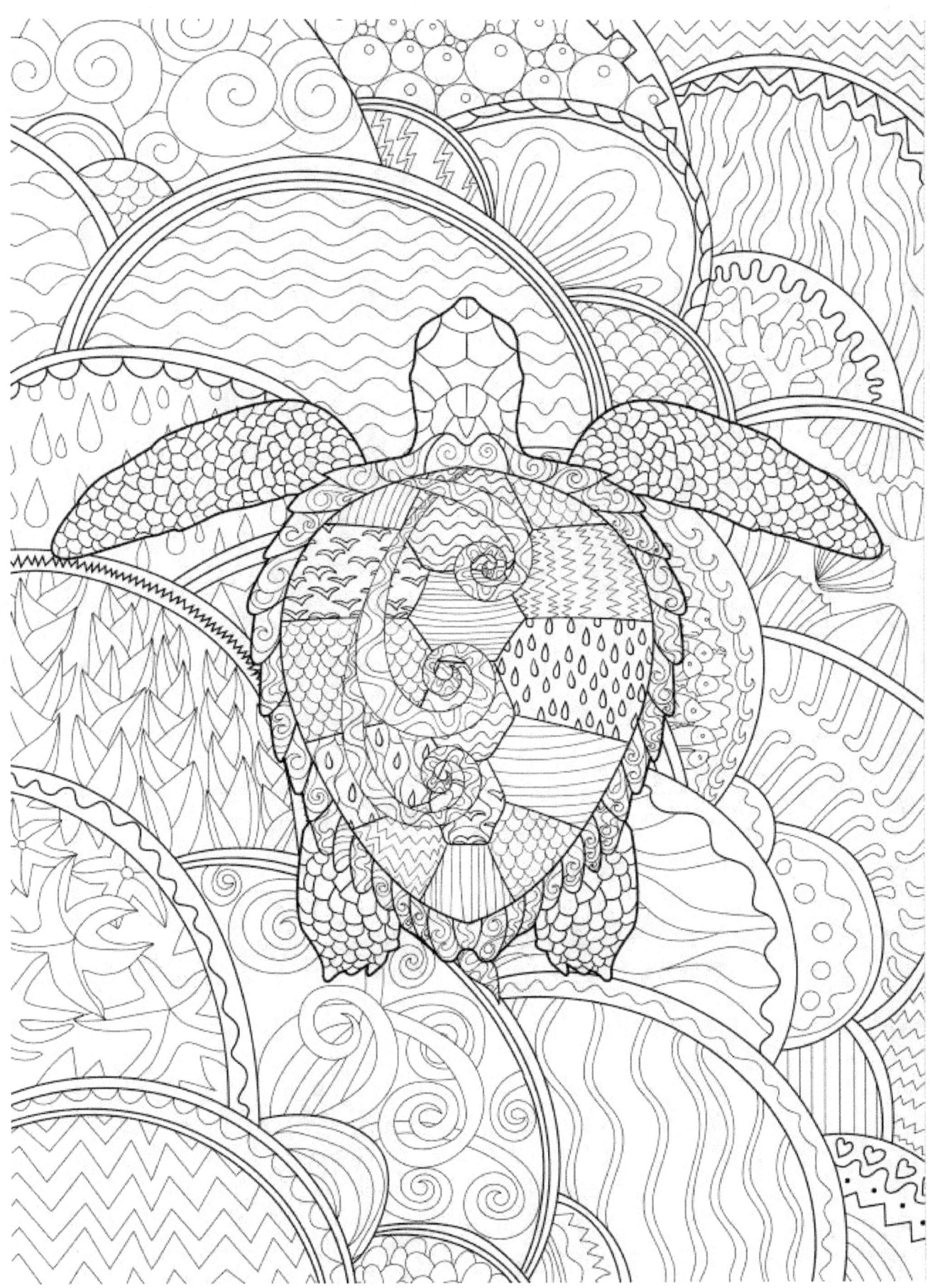

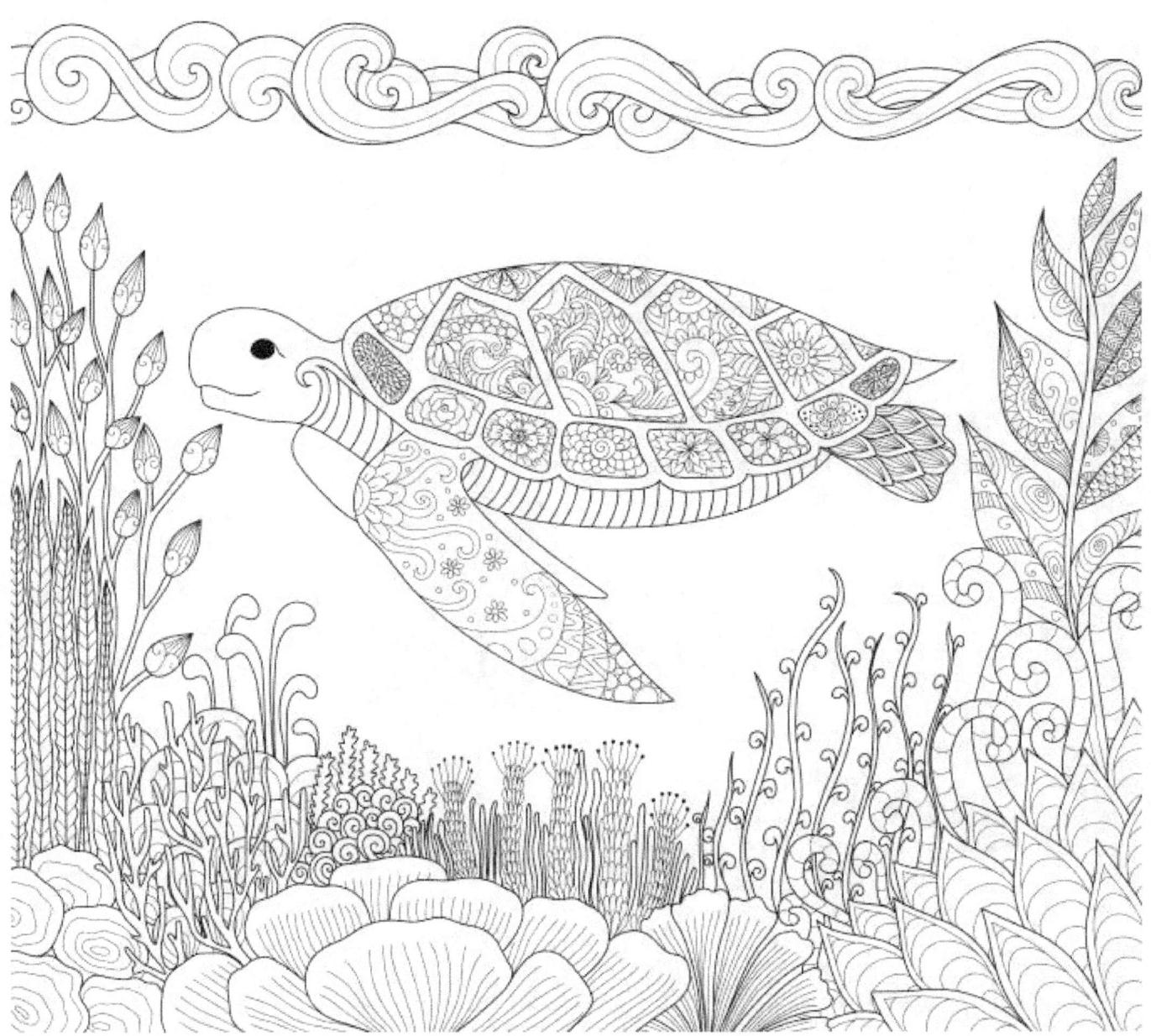

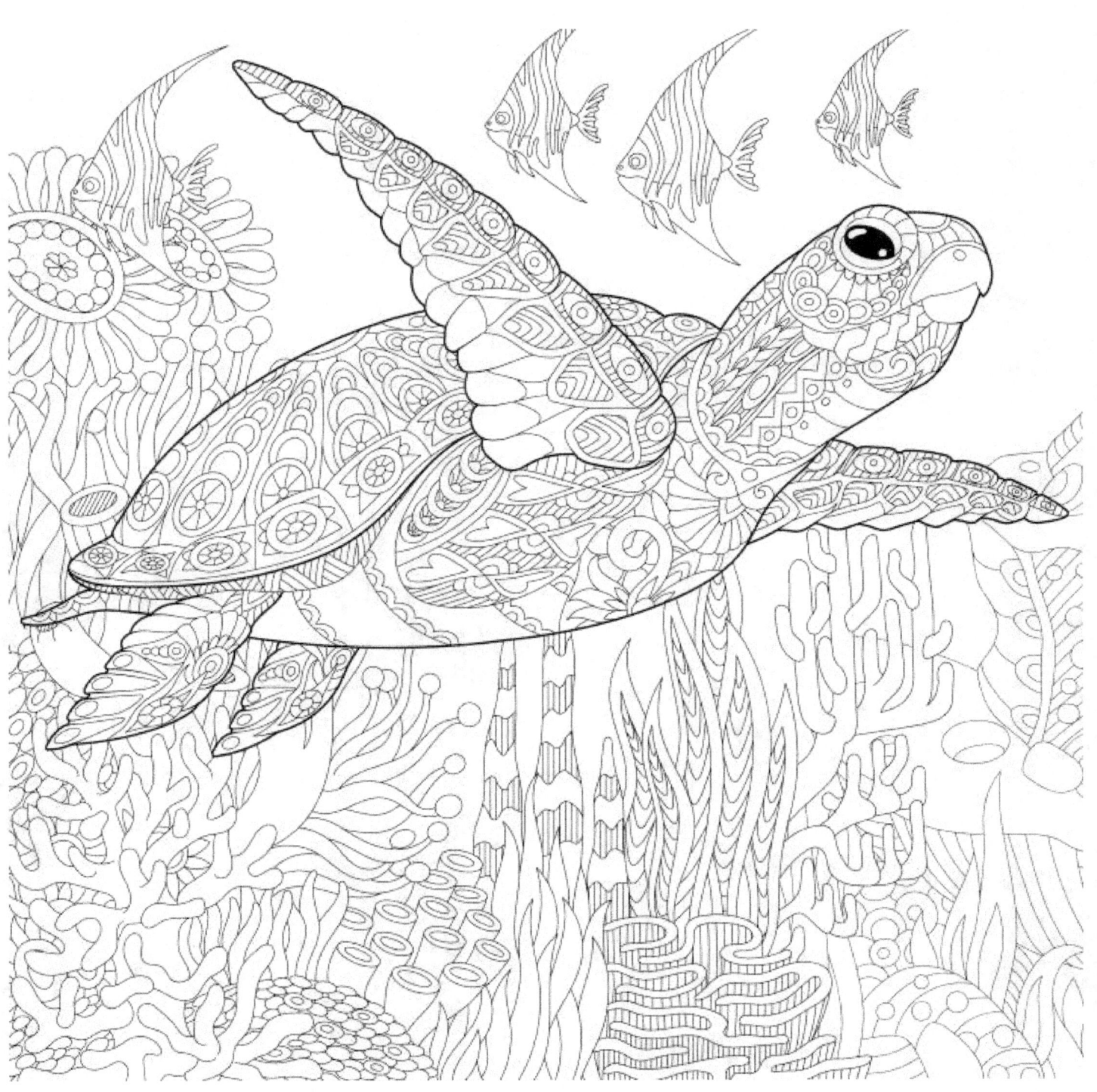

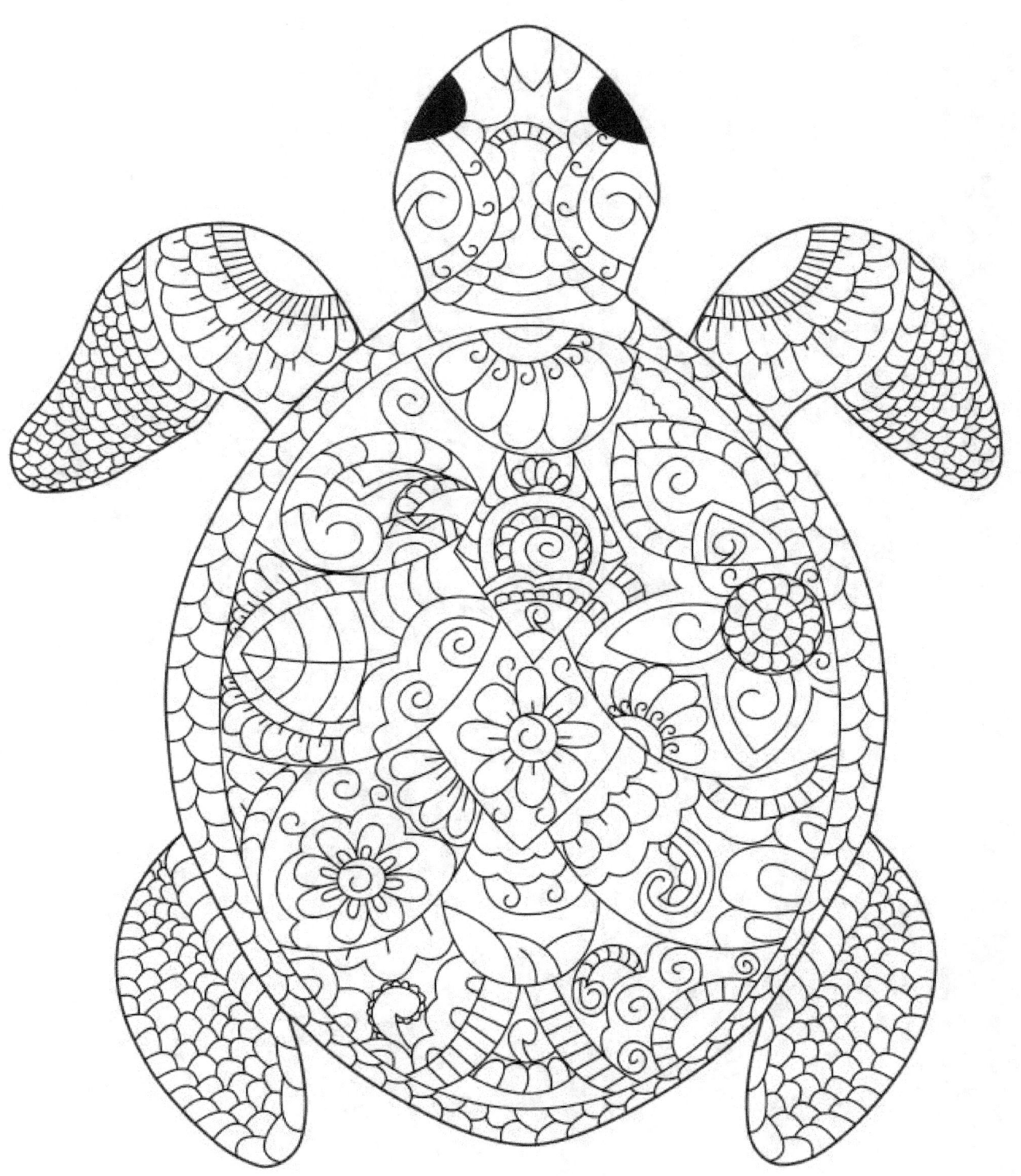

www.ingramcontent.com/pod-product-compliance
Lightning Source LLC
Chambersburg PA
CBHW081011170526
45158CB00010B/3005